REVOLUTION
IN DUBLIN

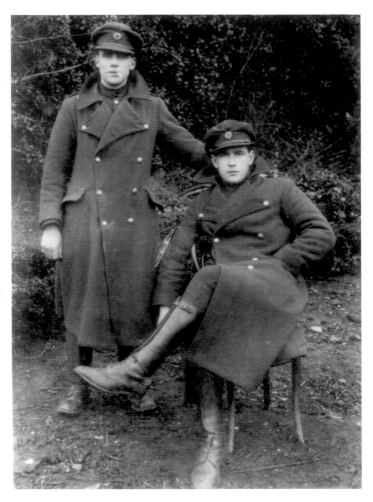

Leo Duffy (*sitting*) and an unidentified National Army soldier. Duffy was a member of F Company, 2nd Battalion, Dublin Brigade, during the War of Independence. He took part in the burning of the Custom House in May 1921 and was imprisoned in Kilmainham Gaol after the operation. Like most of his comrades from the 2nd Battalion he took the pro-Treaty side during the Civil War.

Courtesy of Christopher and Peter Duffy.

REVOLUTION
IN DUBLIN
A PHOTOGRAPHIC HISTORY 1913–23

LIZ GILLIS

MERCIER PRESS
IRISH PUBLISHER – IRISH STORY

This book is dedicated to John Brogan.

A friend to so many, we miss you.

MERCIER PRESS

Cork

www.mercierpress.ie

© Liz Gillis, 2013

ISBN: 978 1 78117 051 9

10 9 8 7 6 5 4 3 2 1

A CIP record for this title is available from the British Library

Printed and bound in the EU.

CONTENTS

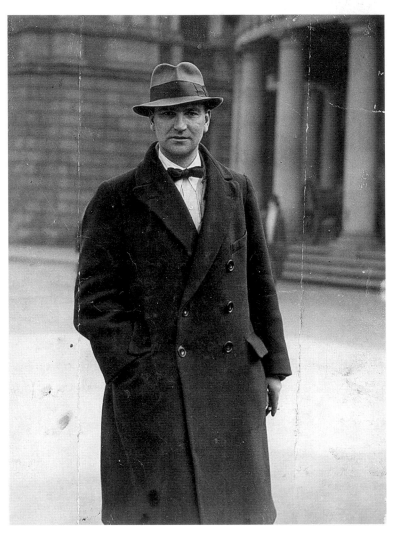

Joe McGrath outside Leinster House, 1922. McGrath was a veteran of the Republican movement having fought in Marrowbone Lane in 1916, after which he was imprisoned in Wormwood Scrubs and Brixton Prison. He was arrested under the 'German Plot' in 1918 and was elected to the Dáil in the general election. He took the pro-Treaty side during the Civil War where he held the rank of major-general. He was also a member of the Provisional Government and director of intelligence of the National Army.

INTRODUCTION

The 1913 Lockout, Home Rule, the First World War, the Easter Rising, the War of Independence, the Civil War. All iconic events that happened in ten short years in this country, which not only created the Ireland we live in today, but also helped generate change around the world. These are the years of the Irish revolution, which saw this country go from being a most valuable dominion of Great Britain to being the country that would initiate the demise of the British Empire. This period has intrigued, excited, inspired and angered generations of people, and thankfully the interest in this period of our history shows no sign of slowing down, especially as we are now in the 'Decade of Centenaries'.

Much has been written on the subject. There are hundreds of books telling the story of the iconic events of the period. And we all know the story of these events so well, whether it be Patrick Pearse reading the Proclamation outside the GPO, or Bloody Sunday, or the death of Michael Collins. The faces of the famous figures of the revolution are instantly recognisable – Pearse, Collins, James Connolly, Éamon de Valera and Arthur Griffith, to name but a few. But what are not so well known are the stories and faces of the people who chose to follow these men.

All conflicts, wars and revolutions need their figureheads, but they also need the ordinary people to follow these leaders

and fight the battles. The aim of this book is to illustrate the story of the events that took place in Dublin between the years 1913–23 as far as possible through images of the ordinary people who were involved. These men and women did not choose a life that brought them hardship and great loss for the glory or rewards they would gain. They did it because they believed in their country's future as a free and independent state. And they chose to become involved in the revolution, even if it meant losing everything, in the hope that their children or grandchildren would not have to fight the same battles. Many suffered for their commitment to the cause of Irish freedom. They lost friends, siblings, spouses and fiancés, or made the ultimate sacrifice themselves, but if that was the price that had to be paid for Ireland's independence, then they were willing to pay it.

Although in the years 1913–23 these men and women were revolutionaries, after the fighting stopped they became husbands, wives, parents, grandparents, aunts and uncles, and many never spoke of their experiences during that time, especially of the bitter and divisive Civil War. But thankfully a photographic record of the period survived and through the photographs chosen for this book the reader is given a glimpse into the lives of the men and women who gave up so much for their country.

There is still much work to be done on the Irish revolution. The main events as well as the main protagonists have been studied in incredible detail. But in order to get a better understanding of the conflict we should now look at the individuals, the ordinary men and women who chose to fight for their country's freedom. By doing this, by focusing on these people, who were our great-grandparents, grandparents, parents,

aunts and uncles, the role that they played in helping to create this state will not be forgotten and we should be able to gain a greater understanding of this period and those involved. It is hoped that this book will, in a small way at least, contribute to this effort.

Where possible I have identified the people in the photographs, as well as the locations and dates. Any mistakes or omissions are my own, and if people recognise individuals not identified in the photographs I would be thrilled if they would contact me so that the necessary additions can be made.

Liz Gillis

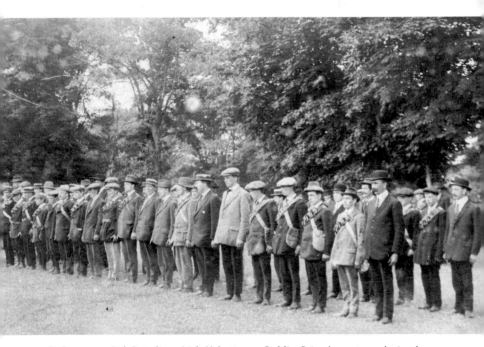

D Company, 3rd Battalion, Irish Volunteers, Dublin Brigade, on parade in the grounds of Sandymount Castle, 1914.
Courtesy of Military Archives Dublin, IE-MA-BMH-CD-58-3.

1913-15:
REVOLUTIONARY BEGINNINGS

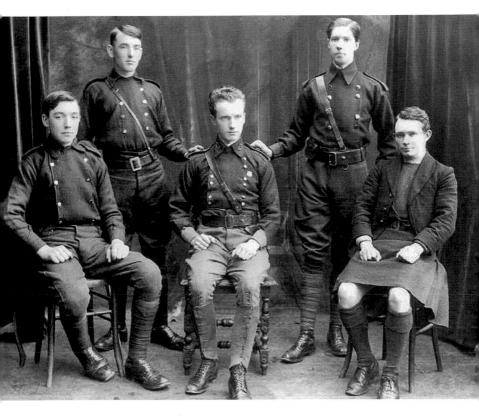

Senior officers of Na Fianna Éireann, *c.* 1913–14. Na Fianna was established in Ireland in 1909 to counteract the influence of the Boys' Brigade and Baden Powell's Boy Scouts. This organisation promoted the politics of Irish independence and when the Irish Volunteers were founded, many of their drill instructors were members of Na Fianna. *Seated, left to right:* Paddy Holohan, Michael Lonergan, Con Colbert. *Standing, left to right:* Garry Holohan, Pádraig Ó Riain.

Courtesy of Eamon Murphy.

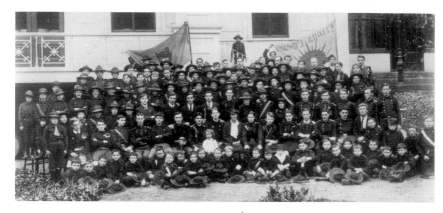

Countess Markievicz seated with Na Fianna Éireann at their Ard-Fheis which took place at the Mansion House, Dublin, on 13 July 1913. Markievicz was one of the founding members of the organisation.
Courtesy of James Langton.

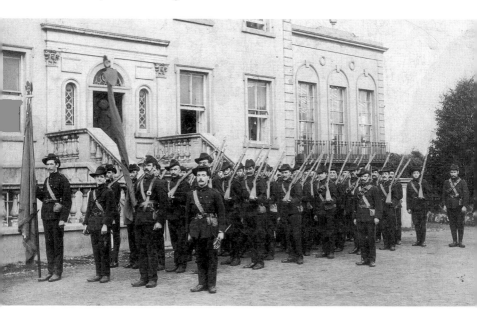

Members of the Irish Citizen Army (ICA) line up in formation, Croydon Park, Fairview. The ICA was established in October 1913 as a workers' defence force during the Dublin Lockout. They would regularly drill in Croydon Park, the grounds belonging to the Irish Trade and General Workers' Union (ITGWU).
Courtesy of Kilmainham Gaol Archives (Hanratty Collection).

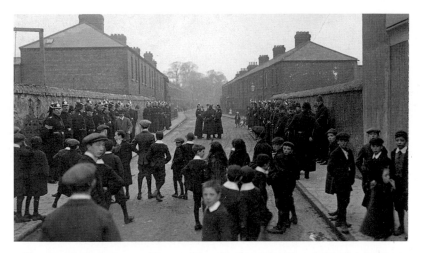

The struggle for better working conditions by the trade unions led to the dismissal of 100 tramway workers and the strike that became known as the Dublin Lockout. The strike began in August 1913 and led to some violent clashes between police and striking workers. Here police in reserve wait in Windsor Avenue, Sunday 30 November 1913.

Courtesy of Kilmainham Gaol Archives, 15PO 1Λ22-17.

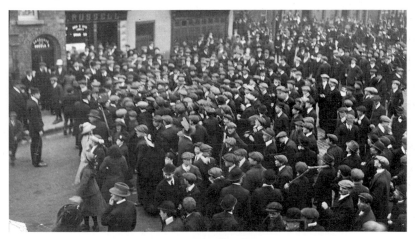

Strikers about to try to force their way through the police cordon which was attempting to stop them reaching a meeting in Croydon Park. With the workers and their families facing increasingly desperate conditions and with little hope of succeeding in their demands, the strike was eventually called off in January 1914.

Courtesy of Kilmainham Gaol Archives, 15PO-1A22-17.

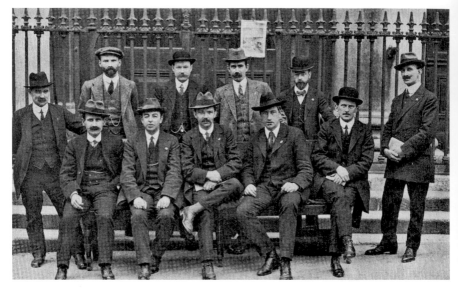

Members of the Irish Trade Union Congress and Labour Party, 1914. James Larkin, founder and leader of the ITGWU, is seated second from right. Standing to the left is James Connolly, who was a founding member of the ICA and who took over as commandant of the organisation in late 1914 as a result of Larkin's decision to travel to America. Under Connolly the ICA was to become a more militant body.
Courtesy of the Irish Labour Museum.

Captain Jack White (*left*) with Francis Sheehy-Skeffington (*right*) leaving the Bridewell, Dublin, after White had been charged with assaulting two police officers in March 1914. White, a Protestant from County Antrim, had co-founded the ICA with James Larkin and James Connolly in 1913. He later joined the Irish Volunteers. Although he did not take part in the Easter Rising, he was later arrested for trying to organise Welsh miners to strike in response to the imprisonment of James Connolly.
Courtesy of Kilmainham Gaol Archives, 13PC-1K43-13.

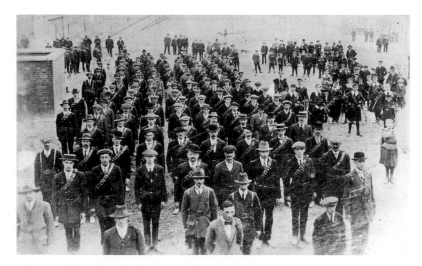

The Irish Volunteers were founded in November 1913 in response to the arming of the Ulster Volunteers (UVF) earlier that year. In this image a large group of Irish Volunteers is seen on parade, 1914. All are in civilian clothes with bandoliers across their shoulders. Members of a pipe band can be seen to the right.

Courtesy of Kilmainham Gaol Archives, 16PC-1A43-07.

Members of Cumann na mBan, the women's auxiliary force to the Irish Volunteers, in Fairview, 1914. Among those standing are Gertie Colly, Esther Wisely, Stascia Toomey and Amee MacDonald. Seated, second from right, is Annie White; it has not been possible to identify the other women.

Courtesy of Kilmainham Gaol Archives, 13PC-1B52-25.

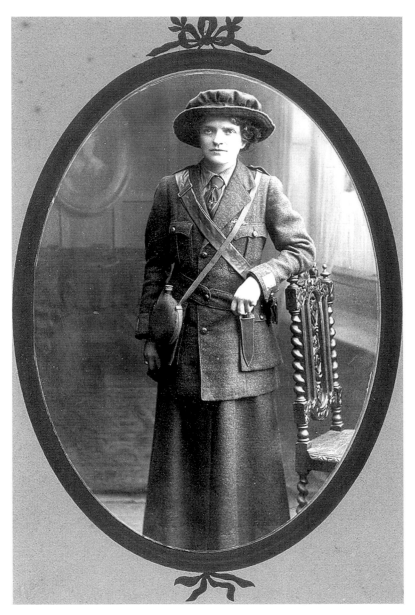

Annie Derham in Cumann na mBan dress. She joined Cumann na mBan upon its inception in 1914. She died in January 1918 in her home in Connaught Street, Dublin.

Courtesy of Kilmainham Gaol Archives, 17PC-1A41-30a.

The Howth gun-running of 26 July 1914 was organised to supply the Irish Volunteers with weapons. Gordon Shepard (*left*) and Erskine Childers (*right*) on board the *Asgard*.

Courtesy of Mercier Archives.

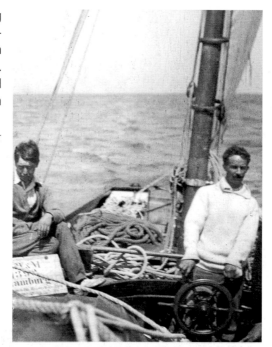

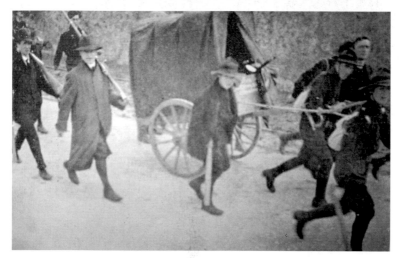

Members of Na Fianna Éireann transporting the rifles landed at Howth. Second from the right is senior officer Eamon Martin. Third from the right is Edward Bracken. Edward's brother John was also present at the Howth gun-running.

Courtesy of Eamon Murphy.

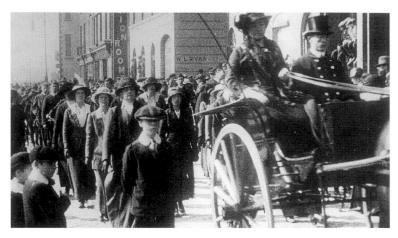

The funeral procession on 29 July 1914 of the victims killed by the British military following the landing of guns at Howth. The Scottish Borderers opened fire on an unarmed crowd that was jeering their failure to stop the Volunteers spiriting away the landed weapons. Mrs Reddin, seated in the trap, was a member of Cumann na mBan. This photograph shows the procession moving down Bachelors' Walk, where the shootings took place.

Courtesy of Kilmainham Gaol Archives, 16PO-1A23-09.

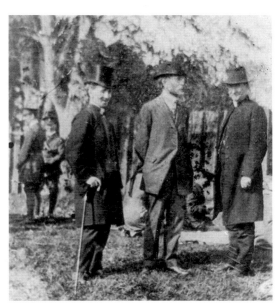

Eoin MacNeill (*centre*), one of the founding members of the Volunteers, with two clergymen at a Volunteer rally in Fairview Park, 1915.

Courtesy of Kilmainham Gaol Archives, 16PO-1A23-03.

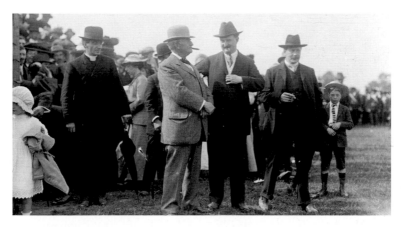

John Redmond, the leader of the Irish Parliamentary Party and advocate of Home Rule, with his son and brother at the Phoenix Park, Easter Sunday, 1915, where a national review of the Volunteers was being held. By this time the Volunteers had split after Redmond pledged the organisation to fight with the Allies in the First World War. The majority of the Volunteers chose to follow Redmond and took the title National Volunteers, while a small minority who remained committed to fighting the British in Ireland kept the name Irish Volunteers.

Courtesy of the National Library of Ireland.

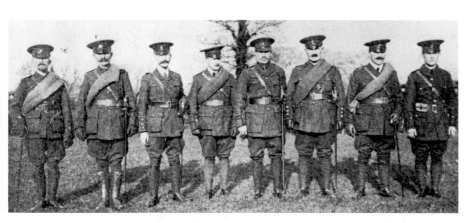

Officers of the 4th Battalion, Dublin Regiment, Irish National Volunteers. *Left to right:* M. G. Dowling, G. Walsh, E. Hynes, J. Dowling, — Whelan, — O'Donnell, W. O'Neill and — Donavan.

Courtesy of Military Archives Dublin, Collins A-0848.

Jeremiah O'Donovan Rossa, lying-in-state in City Hall, Dublin, July 1915. O'Donovan Rossa was a veteran Fenian, who was exiled to America by the British in 1869, where he continued his work to help liberate Ireland. His death and subsequent repatriation for burial to Ireland was a huge propaganda opportunity for the Republican movement. The massive public funeral, which included Patrick Pearse's now famous graveside oration, led to a renewed interest among the population in self-government for Ireland.

Courtesy of Kilmainham Gaol Archives, 16PD-1A11-19.

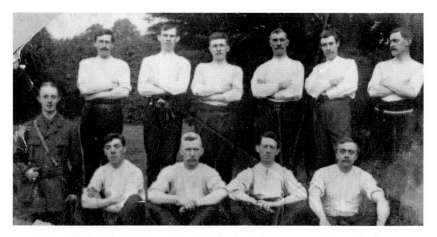

Sports day at St Enda's school, Rathfarnham, 5 September 1915. St Enda's was the school set up by Pearse in 1908 and was a fertile recruitment ground for the Irish Volunteers, who also used its secluded grounds for training. This photograph shows Lieutenant O'Connor-Cor and the tug-of-war team of D Company, 3rd Battalion, Dublin Brigade.

Courtesy of Military Archives Dublin, IE-MA-BMH-CD-58-9.

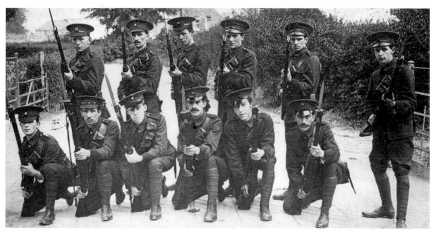

Special section, A company, 4th Battalion, Dublin Brigade. This photograph was taken at Kimmage Drill Hall on 12 September 1915. *Standing, left to right:* Seán Treacy, Paudge Ó Broin, Gabriel Murray, Brian McCormack, Seán Ó Broin and Henry Murray (adjutant). *Kneeling, left to right:* Gerald Murray, Fred Schweppe, Pat Mason, Ed McNamara, Louis McDermott and Denis Dunne.

Courtesy of Kilmainham Gaol Archives, 16PO-1A23-15.

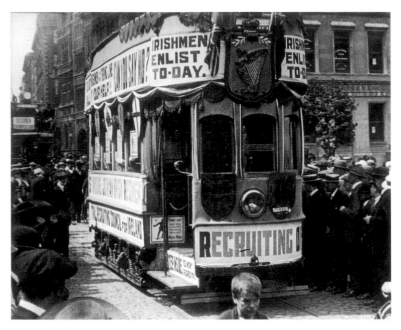

A decorated tram on a recruiting parade for the British Army in Dame Street, 1915. The First World War was seen by the Irish Republican Brotherhood (IRB) as the perfect opportunity to take advantage of Britain's distraction and stage a rebellion.
Courtesy of Kilmainham Gaol Archives, 10PO-1A57-03.

Thomas J. Clarke, one of the architects of the Easter Rising, outside his shop in Parnell Street.
Courtesy of Kilmainham Gaol Archives, 17PC-1A26-24.

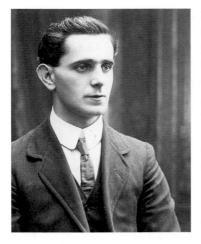

Seán MacDiarmada, who had helped reorganise the IRB along with Bulmer Hobson and Denis McCullough. They were greatly influenced by Tom Clarke, who was their link to the old IRB. MacDiarmada was the most extreme of these younger men and helped recruit many new members to the organisation who were as militantly minded as he was. As a result he was regarded by the British as the most dangerous man in Ireland.

Courtesy of Mercier Archives.

Thomas MacDonagh, poet, lecturer and revolutionary. MacDonagh was sworn into the IRB in 1915 and was swiftly appointed to the military council which planned the 1916 Rising.

Courtesy of Kilmainham Gaol Archives, 16PC-1A43-01.

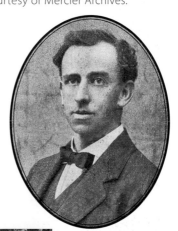

Joseph Mary Plunkett (*left*) with his brother George (*middle*) in 1912. In all three Plunkett brothers, Joseph, George and Jack, took part in the Easter Rising.

Courtesy of Kilmainham Gaol Archives, 13PC-1K43-11b.

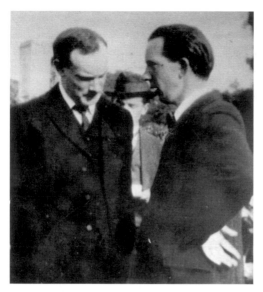

Patrick Pearse (*left*) and his younger brother William. Both were later executed for their participation in the Rising.
Courtesy of the Pearse Museum, 04.0098a.

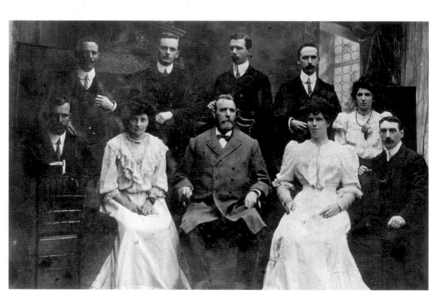

Éamonn Ceannt (*standing, right*) with members of his family. Ceannt was a member of the Gaelic League, IRB and was a founding member of the Irish Volunteers. Commander of the 4th Battalion, Dublin Brigade, during the Easter Rising he commanded the garrison at the South Dublin Union.
Courtesy of Kilmainham Gaol Archives, 17PC-1B52-04.

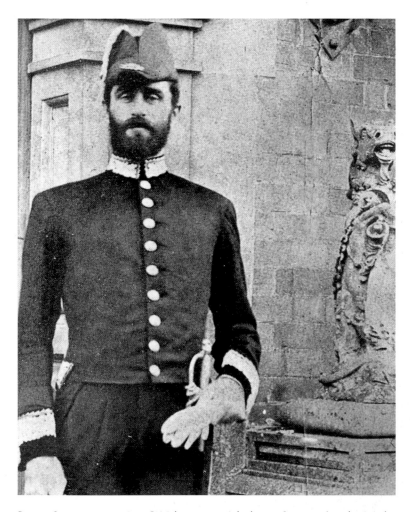

Roger Casement wearing British ceremonial dress. Casement's role in the preparations for the Rising was to try to enlist Irish prisoners-of-war in Germany into an Irish Brigade, which would then fight during the Rising, while also securing from the Germans much-needed weapons and ammunition. The Irish Brigade was not a success and never left Germany. Casement, convinced the Rising would fail, was transported to Ireland in a German U-boat in an attempt to stop it going ahead. He was arrested on landing at Banna Strand, Kerry, and taken to England where he was later put on trial for high treason. He was found guilty and was executed in Pentonville Prison on 3 August 1916.

Courtesy of Mercier Archives.

1916:
ÉIRÍ AMACH NA CÁSCA

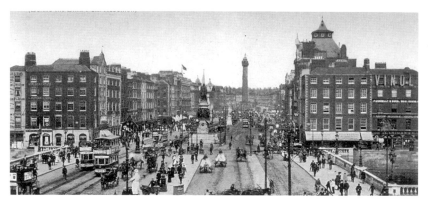

O'Connell Street before the Rising.
Courtesy of Kilmainham Gaol, 17PD-1A18-11c.

Molly O'Reilly. A member of the Irish Citizen Army, she had the honour of hoisting the Tricolour above Liberty Hall on Easter Monday 1916.
Courtesy of Terry Fagan and the Inner City Folklore Project.

Seán Connolly, Irish Citizen Army. Connolly led the assault on Dublin Castle, after which his small party took over City Hall. While on the roof of City Hall he was hit by a sniper's bullet and died, the first rebel to die in the Rising. Also present on the roof were Dr Kathleen Lynn and Nurse Brigid Davis, who both tried to save him. His younger siblings, George, Mattie, Eddie and Katie, were under his command at City Hall.
Courtesy of Kilmainham Gaol Archives, 17PD-1A18-08.

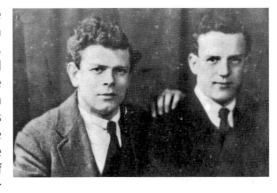

Joe (*left*) and Mattie Connolly, together with their brothers Seán, Eddie and George, and their sister Katie, were all members of the Irish Citizen Army. Joe was also a member of the Dublin Fire Brigade. He fought in the College of Surgeon's during Easter Week. Interned in Frongoch, upon his release he rejoined the Fire Brigade. Through his position in the Fire Brigade he helped in many IRA operations during the War of Independence and the Civil War. Mattie was the youngest of the brothers involved.

Courtesy of Mike Connolly.

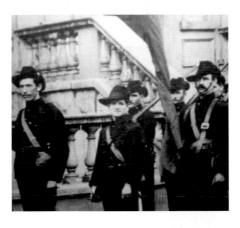

Katie Barrett (née Connolly) (*centre*) in her Irish Citizen Army uniform at Croydon Park.

Courtesy of Mike Connolly.

Thomas George Connolly on his wedding day in January 1918. George Connolly, like his siblings, was a member of Na Fianna Éireann before he joined the Citizen Army. He helped capture the Guard Room in Dublin Castle and later he and Mattie helped take over Henry and James Outfitters on the corner of Parliament Street. The two of them evaded arrest after the Rising ended, and both went on the run.

Courtesy of Mike Connolly.

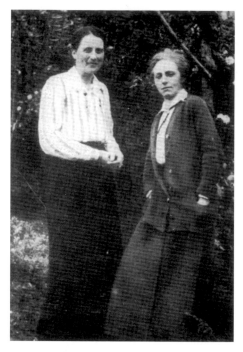

Dr Kathleen Lynn (*left*) and Madeline Ffrench Mullen. Lynn was a member of the Irish Citizen Army and was with Seán Connolly when he was fatally wounded at City Hall. She opposed the Treaty and was imprisoned for her activities during the Civil War. Ireland at the time suffered high rates of infant mortality and to combat this Lynn and Ffrench Mullen set up St Ultan's Hospital in 1919, Ireland's first infant hospital. Lynn also pioneered the use of the BCG vaccine in Ireland.
Courtesy of the Irish Labour Museum.

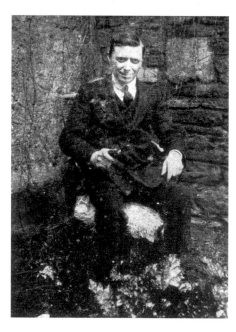

Ernest Kavanagh, distinguished political cartoonist. His works in the ITGWU newspapers during the Lockout vividly summed up the plight of the workers against the employers, most notably William Martin Murphy. Although not a member of the Irish Volunteers or the Citizen Army, he was one of the first casualties in the Easter Rising. He was shot by a British sniper positioned in the Custom House while trying to gain entry into Liberty Hall on Tuesday 25 April. He was thirty-two years old.
Courtesy of Military Archives Dublin, IE-MA-BMH-P-27-002.

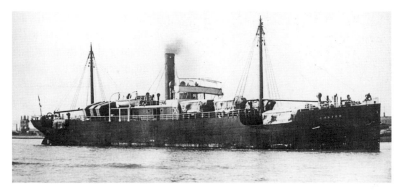

Originally called the *Castro*, and later renamed the *Aud*, this ship was sent by the Germans with a consignment of arms destined for use in the Easter Rising. It arrived off the coast of Ireland at Tralee on 20 April, but failed to make contact with the Volunteers and was caught in a British blockade. The German crew scuttled the ship in Cork harbour rather than let the British capture it, and were interned for the rest of the war.

Courtesy of Mercier Archives.

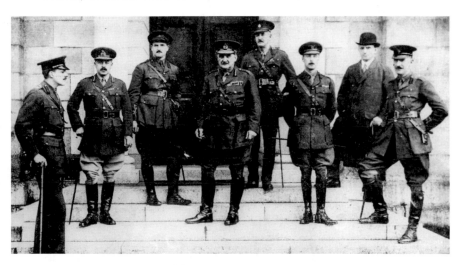

General Sir John Maxwell and his staff, 1916. Maxwell was sent to Ireland to put down the Rising and arrived on Friday 28 April. *From left:* Captain the Marquis of Anglesey, Brig.-General Hutchinson, Captain Bucknill, General Sir J. Maxwell, Colonel Taylor, Captain Prince Alexander of Battenburg, General Byrne and Colonel Stanton.

Courtesy of Kilmainham Gaol Archives, 17PC-1A44-11.

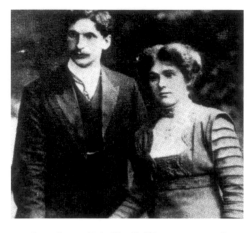

Éamon de Valera with his bride, Sinead Flanagan, 8 January 1910. De Valera was commandant of the 3rd Battalion and his role during the Rising was to impede the advance of reinforcements of British troops that would undoubtedly arrive from England. Like those of his comrades, de Valera's garrison, based around Boland's Mills, was greatly reduced in numbers due to Eoin MacNeill's countermanding order. However, through careful positioning of his men, his command area not only saw possibly the heaviest fighting, but also inflicted the highest casualties upon the British forces.

Courtesy of Kilmainham Gaol Archives 13PC-1B14-12.

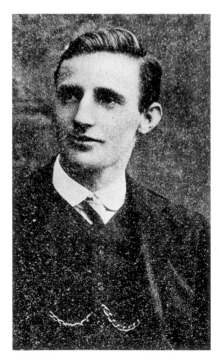

Lieutenant Michael Malone, C Company, 3rd Battalion, Dublin Brigade, was in charge of seventeen men, who, under the orders of Éamon de Valera took up positions around Mount Street Bridge. He held No. 25 Northumberland Road, with Seamus Grace, while his section commander, George Reynolds, took over Clanwilliam House with six men. Another party of men took over the parochial hall which lay between the two outposts. They were to see some of the heaviest fighting, and inflicted the most casualties on the British forces during the Rising. Malone was killed defending No. 25. He was twenty-five years old.

Courtesy of Kilmainham Gaol Archives, 17PC-1A44-03.

George Reynolds, section commander in charge of the outpost in Clanwilliam House, was killed in action defending that position.

Courtesy of Kilmainham Gaol Archives, 17PC-1A44-05.

Volunteer Patrick Doyle, E Company, 3rd Battalion. He fought in Clanwilliam House and was killed in action while trying to prevent British reinforcements entering the city. He was thirty-six years old.

Courtesy of Mercier Archives.

Volunteer Richard Murphy, killed in action at Clanwilliam House. He was a member of C Company, 3rd Battalion. He was twenty-four years old.

Courtesy of Mercier Archives.

No. 25 Northumberland Road.
Courtesy of Mercier Archives.

The ruins of Clanwilliam House.
Courtesy of Mercier Archives.

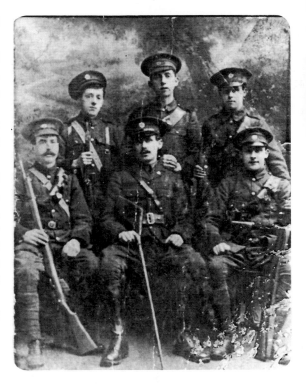

Members of A Company, 3rd Battalion.

Seated, left to right: Seán Murphy (company adjutant), Tim Finn (first lieutenant), Tommy Byrne.

Standing, left to right: Seán Doyle, Jimmy Pender, Christy Byrne.

This photograph was taken prior to the Easter Rising. Finn fought in the Rising, but later joined the 1st Battalion, Irish Guards, British Army, and was killed in the war. He was thirty-six years old.

Courtesy of Bernard Bermingham

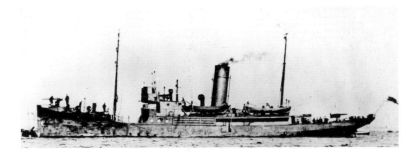

The *Helga* was brought up the Liffey and used by the British to shell Volunteer strongholds in the city. First the crew targeted Liberty Hall, then trained their gun on O'Connell Street. The ship came under heavy fire from a small party of Volunteers in Hodgkins and Hodgkins, who actually managed to delay her advance upriver. However, their guns were no match for the *Helga* and her gun had a devastating effect on the city.

Courtesy of Mercier Archives.

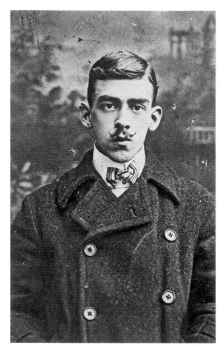

Thomas Dickson was a journalist who worked on such loyalist publications as *The Eye Opener*. Arrested on 25 April with another journalist, Patrick McIntyre, by Captain J. C. Bowen-Colthurst, he was executed in Portobello Barracks with McIntyre and Francis Sheehy-Skeffington. None of them were involved in the fighting during Easter Week.

Courtesy of Kilmainham Gaol Archives, 17PD-1A18-17.

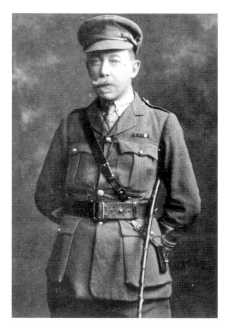

Major Sir Francis Vane, second-in-command, Portobello Barracks, insisted that Bowen-Colthurst be arrested after the killings. Instead, he was relieved of his position in Portobello and Bowen-Colthurst was promoted. Bowen-Colthurst was eventually arrested and court-martialled. He was found guilty but insane and served less than two years in an asylum for his crimes.

Courtesy of the Irish Labour Museum.

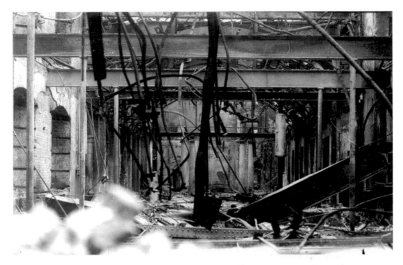

The interior of the GPO after it was destroyed by fire during the Rising.
Courtesy of Kilmainham Gaol Archives, 17PC-1A54-24d.

Eilís Ní Riain in Cumann na mBan uniform. She joined Cumann na mBan in 1915 and took part in the Easter Rising. She was in Reis' Chambers opposite the GPO and carried despatches between O'Connell Street and Church Street while carrying out first aid duties. She was elected to the Executive of Cumann na mBan in October 1920.
Courtesy of Military Archives Dublin, BMH-CD-202.1.

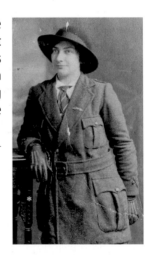

Captain Thomas Weafer, E Company, 2nd Battalion, Dublin Brigade, was killed in action on 26 April while defending the Volunteer outpost in the Hibernian Bank, Lower Abbey Street. He was twenty-six years old.
Courtesy of Kilmainham Gaol Archives, 17PD-1A18-17.

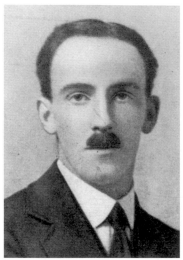

Edward Daly, commandant of the 1st Battalion, Dublin Brigade, in charge of the garrison in the Four Courts and the surrounding area. After Mount Street, this area, including North King Street and the Mendicity Institution, saw some of the most intensive fighting during the Rising. Daly was executed, following his court martial, in Kilmainham Gaol on 4 May, twenty-four hours after his brother-in-law, Thomas Clarke. He was twenty-five years old.

Courtesy of Kilmainham Gaol Archives, 17PD-1A11-29.

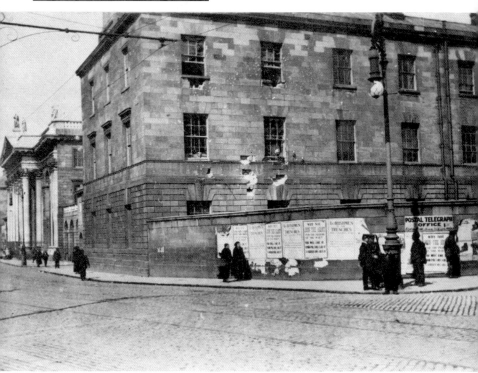

Damage to the Four Courts after the British bombardment.

Courtesy of Mercier Archives.

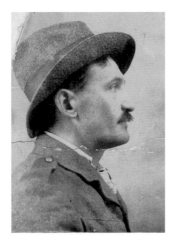

Mugshot of Frank Fahy, 1st Battalion, Dublin Brigade. Fahy was under the command of Edward Daly, fighting in the North King Street area. This photograph was taken in Mountjoy Jail on 8 May 1916.

Courtesy of Kilmainham Gaol Archives, 17PO-1A24-14.

Volunteer Peter Connolly, killed in Easter Week during the fighting in North King Street. Here Connolly is wearing his Volunteer uniform, together with a bandolier.

Courtesy of Kilmainham Gaol Archives, 17PO-1A24-06a.

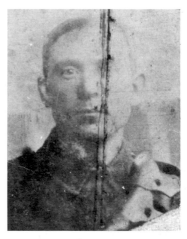

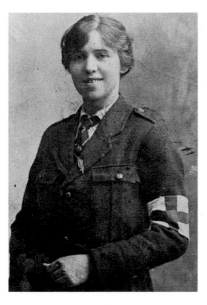

Emily Elliot in her Cumann na mBan uniform wearing a Red Cross armband. During the Rising she carried out first aid duties, assisting Fr Augustine in the Four Courts area.

Courtesy of Kilmainham Gaol Archives, 17PO-1A24-17.

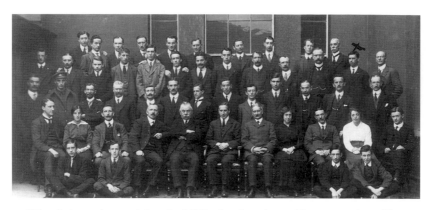

This photograph was taken in 1915, showing the traffic manager's staff at Kingsbridge (now Heuston) Station. Seán Heuston is standing second from right, in the second row from the back, identified by an X. He served under Edward Daly during the Rising, and was positioned in the Mendicity Institution on the south side of the Liffey. His orders were to delay British troops coming into the city from Victoria (now Collins) Barracks. With his small garrison of less than twenty men, he successfully delayed the troops for over two days, finally surrendering his position on Wednesday 26 April. Heuston was executed in Kilmainham Gaol on 8 May. He was twenty-five years old.

Courtesy of Kilmainham Gaol Archives, 16PC-1C456-21.

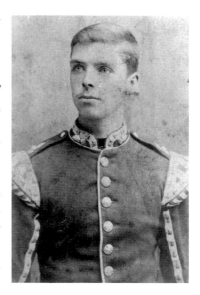

Michael Mallin in his British Army uniform, India, c. 1899. He was from the Liberties in Dublin. Discharged from the army in October 1901, he became a weaver by trade. An advocate of workers' rights, he became very close to James Connolly, and joined the Irish Citizen Army upon its inception. He was the commandant in charge of the garrison which took over St Stephen's Green and the College of Surgeons. Executed in Kilmainham Gaol on 8 May, he was forty-two years old and left behind a widow and five young children.

Courtesy of Kilmainham Gaol Archives, 17PC-1B52-07.

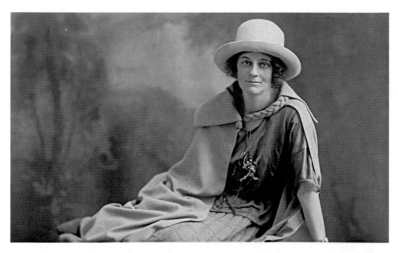

Constance Markievicz was Michael Mallin's second-in-command in St Stephen's Green and the College of Surgeons. She was a member of the Irish Citizen Army and president of Cumann na mBan. Like her commanding officer, she was court-martialled and sentenced to death, but the sentence was later commuted to life imprisonment. She died in 1927.

Courtesy of Kilmainham Gaol Archives, 20PD-1A18-29.

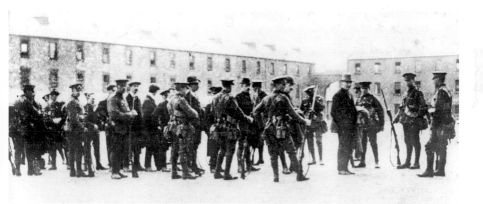

Irish Volunteers under guard in Richmond Barracks, Inchicore, after the surrender. The man in civilian dress looking at the camera is Major John MacBride, who fought alongside Thomas MacDonagh in Jacob's Biscuit Factory. He was no stranger to the authorities, having fought against the British in the Boer War. He was executed in Kilmainham Gaol on 5 May.

Courtesy of Kilmainham Gaol Archives, 17PC-1A44-21b.

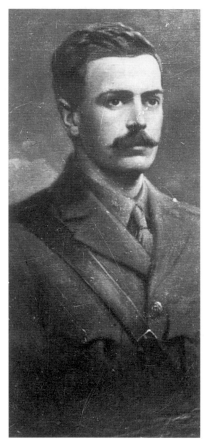

Michael O'Hanrahan. Born in New Ross, County Wexford, he was a member of the Gaelic League and Sinn Féin. He was a founder member of the Irish Volunteers and became quartermaster-general of the organisation. He was second-in-command to Thomas MacDonagh in Jacob's Biscuit Factory and was executed in Kilmainham Gaol on 4 May. He was thirty-nine years old.

Courtesy of Kilmainham Gaol Archives, 17PC-1A44-19.

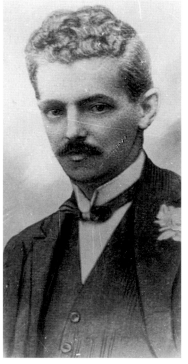

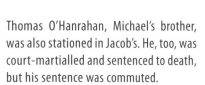

Thomas O'Hanrahan, Michael's brother, was also stationed in Jacob's. He, too, was court-martialled and sentenced to death, but his sentence was commuted.

Courtesy of Kilmainham Gaol Archives, 17PC-1A44-19.

Volunteer Seán McLoughlin, who was made commandant of the Dublin Brigade by James Connolly just before the surrender. He is seen here at the rear of the GPO – the photograph was apparently taken during Easter Week. Note the books and ledgers behind his head, showing what the Volunteers used to barricade the windows.

Courtesy of Kilmainham Gaol Archives, 17PC-1B14-24.

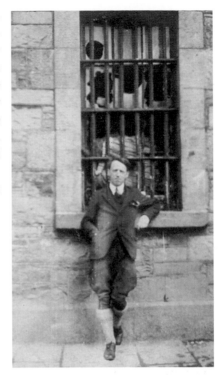

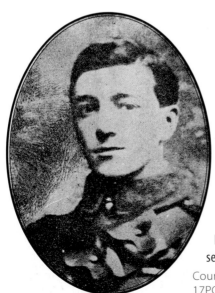

Volunteer Charles Stuart Bevan. A member of the 1st Battalion, Dublin Brigade, Bevan fought under Edward Daly in the Four Courts and was sentenced to death at his court-martial. The sentence was later commuted to three years' penal servitude.

Courtesy of Kilmainham Gaol Archives, 17PC-1A44-09.

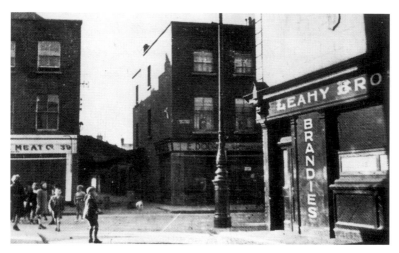

The doorway of Leahy Brothers public house at the corner of Moore Street and Sackville Lane, now O'Rahilly Parade. It was here that The O'Rahilly was fatally wounded while leading an advance party of Volunteers up Moore Street from the GPO after their position there became untenable. They were attempting to reach the Williams and Woods factory in Parnell Street to set up a new headquarters. He was thirty-nine years old when he died on 28 April.

Courtesy of Mercier Archives.

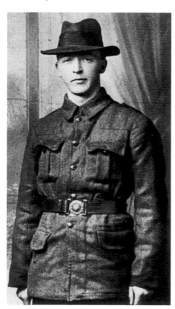

Volunteer Patrick Shortis was a member of F Company, 2nd Battalion, Dublin Brigade. Originally from County Kerry, he moved to Dublin to study. He fought in the GPO during the Rising and was killed in 'O'Rahilly's Charge' on 28 April.

Courtesy of Mercier Archives.

Nurse Elizabeth O'Farrell had been in the GPO throughout Easter week, and it fell to her to deliver Patrick Pearse's offer of surrender to General Lowe on Saturday 29 April. After Lowe's acceptance of unconditional surrender, O'Farrell was then made to bring the order to the Volunteer garrisons throughout the city. She was later imprisoned in Kilmainham Gaol.

Courtesy of Mercier Archives.

Marcella Cosgrave in Cumann na mBan uniform. From George's Quay, Dublin, Marcella was a founding member of Cumann na mBan and participated in the Easter Rising, fighting in Marrowbone Lane Distillery. She was imprisoned in Kilmainham Gaol after the surrender. She died in 1938 aged sixty-three.

Courtesy of Kilmainham Gaol Archives, 2012.0131.

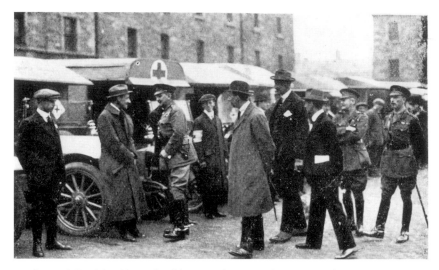

General Sir John Maxwell addressing drivers and orderlies of the ambulance service after the Rising.

Courtesy of Kilmainham Gaol Archives, 17PC-1A44-06.

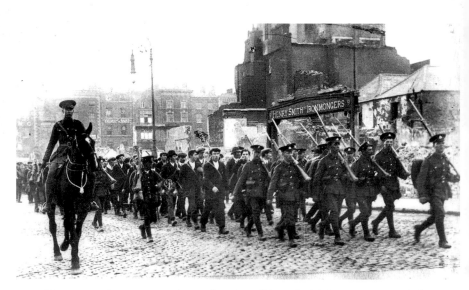

Prisoners under escort march past the ruins of Henry Smith Ironmongers on their way to the docks to be sent to prisons in England at the start of May 1916.

Courtesy of Kilmainham Gaol Archives, 17PC-1A54-25.

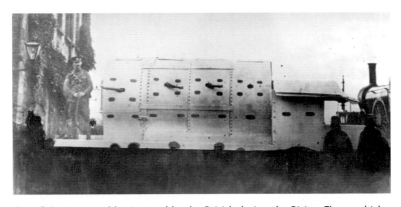

One of the armoured lorries used by the British during the Rising. These vehicles were constructed in Inchicore Railway Works, using locomotive smoke boxes mounted on lorries. They were used with great effect against the rebel strongholds on O'Connell Street.

Courtesy of Military Archives Dublin, IE-MA-BMH-P-19-001.

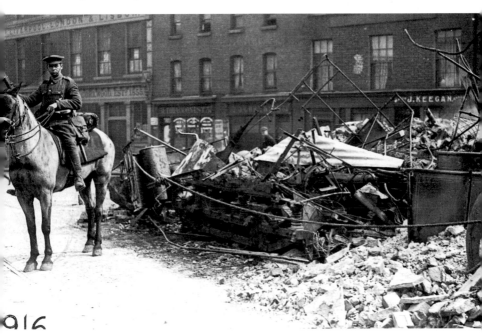

A British soldier on duty beside the burnt-out shell of a tram that was used as part of a barricade by the Volunteers.

Courtesy of Topical Press/Mercier Archives.

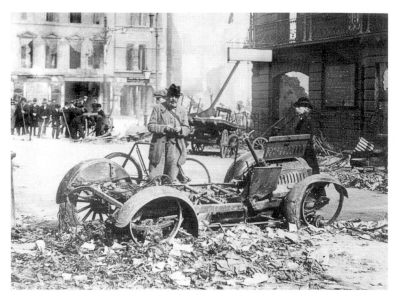

The burnt-out shell of The O'Rahilly's car in Prince's Street. The ruins on the right are those of the Metropole Hotel. In the background are the ruins of the Imperial Hotel. Standing beside the car is the late T. W. Murphy, who was a famous Dublin sports journalist. In front of The O'Rahilly's car can be seen burnt ledgers from the GPO which, along with O'Rahilly's car, formed part of a barricade.

Courtesy of Mercier Archives.

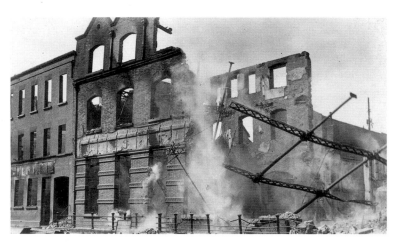

A building being demolished after the Rising.

Courtesy of Mercier Archives.

British troops searching the River Tolka for weapons, after the Rising.
Courtesy of the National Library of Ireland.

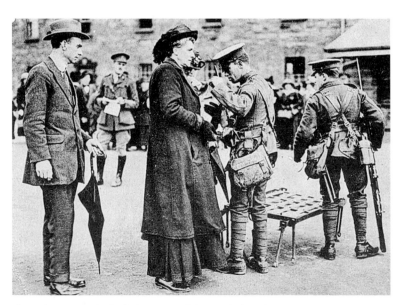

The military search the belongings of visitors before they are allowed to see the prisoners in Richmond Barracks.
Courtesy of Kilmainham Gaol Archives, 17PD-1A12-21.

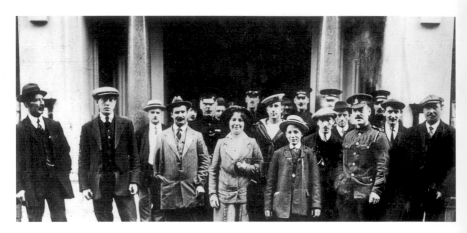

Witnesses at Roger Casement's trial in London, 1916. Casement was found guilty of high treason and sentenced to death. He was executed in Pentonville Prison on 3 August 1916.

Courtesy of Mercier Archives.

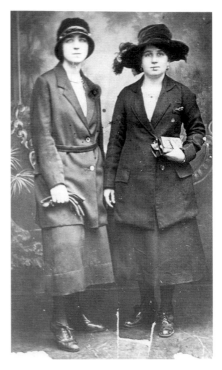

Margaret Farrell Craven (*left*) and Agnes Craven Brady. Sisters-in-law Margaret and Agnes were members of Cumann na mBan and both lived in the Liberties area in Dublin. Margaret took part in the Rising and died in 1994, aged ninety-three. Agnes died in 1965; she was sixty-five years old.

Courtesy of Kilmainham Gaol Archives, 17PC-1B52-29.

Grace Gifford Plunkett. It was her wedding to Joseph Plunkett in Kilmainham Gaol just a few hours before Joseph's execution that saw public opinion begin to change from one of anger against the rebels into one of sympathy. This photograph was taken in Joseph's home at Larkfield, Kimmage, in October 1916.

Courtesy of Kilmainham Gaol Archives, 17PC-1B53-01.

Below: Michael Mallin's widow Agnes and his five children, the youngest of whom never saw his father as he was born after his execution.

Courtesy of Kilmainham Gaol Archives, 17PC-1B52-07c.

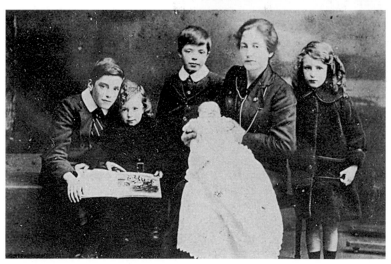

1917-19:
RESURGENCE

Volunteer Joseph McGill upon his return from Frongoch Internment Camp. The men arrested after the Rising were initially interned in a number of prisons in England. However, many of them were then sent to Frongoch Internment Camp in Wales. McGill, who had fought in the GPO, was initially imprisoned in Knutsford. The bulge showing in the lower half of the jacket was a Bible which he smuggled from his condemned cell in Knutsford to Frongoch. McGill kept the Bible with him throughout his internment. The last prisoners in Frongoch were released just before Christmas 1916.

Courtesy of Kilmainham Gaol Archives, 2012.0164.

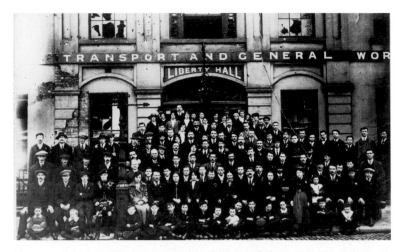

Members of the Irish Citizen Army outside the ruins of Liberty Hall. The photograph was taken either in December 1916 or during Easter 1917. Amongst those in the photograph in the second row (*sitting beside the post to the left*) is Winifred Carney. Second to her right is Helena Molony and fifth to her right is Kathleen Lynn. All three women took part in the Rising.

Courtesy of Military Archives Dublin, IE-MA-BMH-CD-119-3-5.

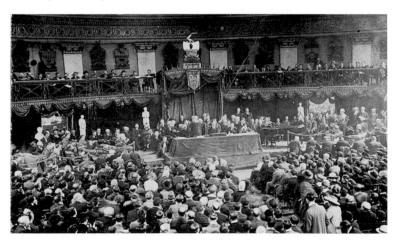

Count Plunkett's Convention, held in the Mansion House, Dublin, 19 April 1917. This convention was held to appoint a National Council that would seek representation at any peace conference after the war, so that Ireland could assert her right to claim independence from Britain.

Courtesy of Kilmainham Gaol Archives, 18PD-1A17-22.

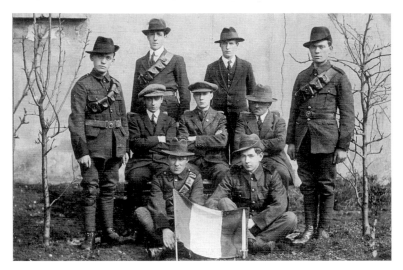

The survivors of the Battle of Mount Street Bridge. *Standing, left to right:* Thomas Walsh, Patrick Doyle, Paddy Roe and James Walsh. *Seated, left to right:* Byrne, either Daniel or Paddy, James Grace and Joe Clarke. *Sitting on the ground, left to right:* Willie Ronan and Jim Doyle. This photograph was taken on Easter Sunday 1917 in the garden of the house that Lieutenant Michael Malone lived in on South Circular Road. The photograph was taken by John Reynolds, the father of George Reynolds who died at Mount Street.

Courtesy of Mercier Archives.

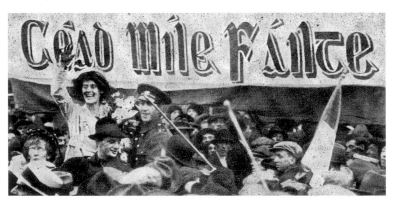

It was not only men who were imprisoned following the Rising. This image shows Countess Markievicz on her return to Dublin from her imprisonment in England, June 1917, arriving at Liberty Hall.

Courtesy of Kilmainham Gaol Archives, 18PC-1A25-13.

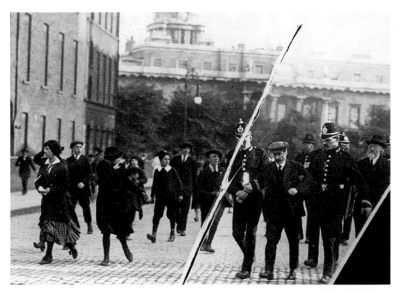

The police arresting Cathal Brugha and Count Plunkett (*far right*), at a meeting in Beresford Place, 10 June 1917. The meeting was held to demand that prisoners sentenced to penal servitude after the Rising should be given prisoner-of-war status. The meeting was proclaimed by the police and when they tried to break it up they were attacked by the crowd. An officer, Inspector Mills, was killed after being struck with a hurley. The Custom House can be seen in the background.

Courtesy of Kilmainham Gaol Archives, 18PC-1A25-20.

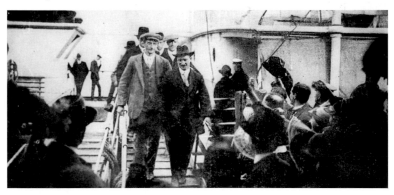

Éamon de Valera (*standing left on the gangway*) returns from prison in England, June 1917. He had been sentenced to death after the Rising, but the sentence was commuted to life imprisonment. He was held in Lewes Prison until his release.

Courtesy of Mercier Archives.

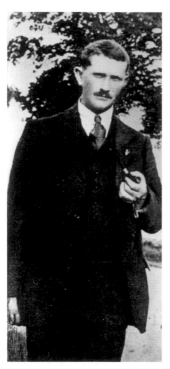

Thomas Ashe, commandant at the Battle of Ashbourne 1916, was sentenced to death for his part in the Rising. The sentence was later commuted to life imprisonment. With the leadership of the IRB gone after the executions in 1916, Ashe was elected president of the Supreme Council of the IRB. He was freed in June 1917 along with de Valera, but was re-arrested in August 1917 for making a seditious speech. Imprisoned in Mountjoy Jail, he began a hunger strike, demanding prisoner-of-war status. He died as a result of force-feeding in September 1917.

Courtesy of Mercier Archives.

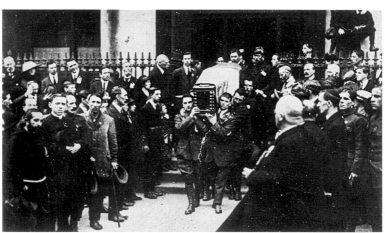

The funeral of Thomas Ashe, September 1917. A party of Volunteers acts as pallbearers carrying the coffin draped in the Irish Tricolour. Members of the Citizen Army are also present, as are the British military, seen on the far right.

Courtesy of Kilmainham Gaol Archives, 18PD-1A13-27.

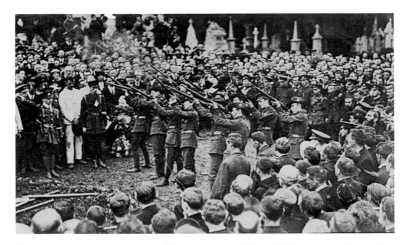

The firing party at the grave of Thomas Ashe. Michael Collins gave the oration at the graveside. Collins eventually succeeded Ashe as president of the Supreme Council of the IRB during the War of Independence.

Courtesy of Kilmainham Gaol Archives, 18PD-1A13-20.

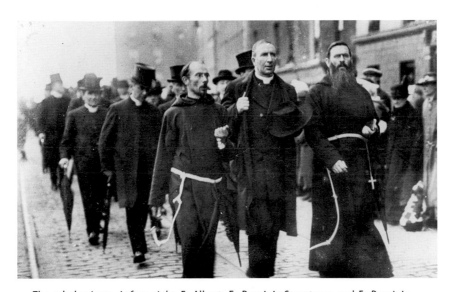

The rebel priests. *Left to right:* Fr Albert, Fr Dominic Sweetman and Fr Dominic, Capuchin Friars, at the funeral of Thomas Ashe. Their support to the Volunteers and the revolutionary movement throughout the period 1916–23 was unwavering.

Courtesy of Kilmainham Gaol Archives, 18PC-1A54-27.

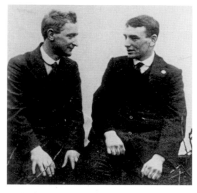

Eamon Martin (*left*) and Garry Holohan. Both were members of Na Fianna from its inception and they fought together in North King Street during the Rising. Holohan was arrested after the surrender, but Martin, although wounded, managed to evade capture. Determined to keep Na Fianna together, a Provisional Committee was established with Martin as its chairman. Holohan was released at the end of 1916 and on his return to Dublin took over as commandant when Martin went to America to fully recover from his wounds. Martin returned to Ireland in 1917 and resumed his command. Together they reorganised, trained and prepared Na Fianna for its role in the War of Independence. The members of Na Fianna proved themselves vital to the independence movement during those years.

Courtesy of Kilmainham Gaol Archives, 18PO-1A31-08.

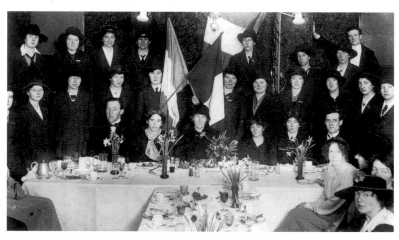

Kathleen Clarke's return from prison in 1918. Before the Rising her husband Tom Clarke gave her a list of the names of men who would reorganise the movement if the Volunteer leadership did not survive. He also gave her gold which she used to set up the Volunteer Dependants' Relief Fund. Arrested under the 'German Plot', she was imprisoned in England. A celebration was held in her honour upon her release and was attended by members of Cumann na mBan and others, including Kathleen Clarke (*centre*), Harry Boland (*seated left*) and Michael Staines (*seated right*).

Courtesy of Kilmainham Gaol Archives, 19PO-1A33-29.

Volunteer Joe Lynch, wearing his Volunteer uniform, was a member of A Company, 3rd Battalion, Dublin Brigade. This photograph was taken in 1918. Following the release in 1917 of the men imprisoned after the Rising, reorganisation of the Volunteers quickly began to make this an effective force with one goal in mind: independence.

Courtesy of Kilmainham Gaol Archives, 18PC-1A58-22.

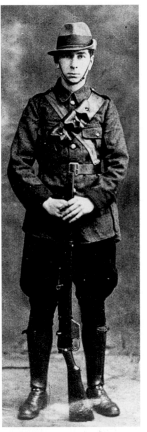

Below: Members of Sinn Féin at the party's headquarters at No. 6 Harcourt Street, October 1918. *Back row, left to right:* Seán Milroy, Robert Brennan. *Second row, left to right:* Diarmuid O'Hegarty, Michael Nunan, Dan McCarthy, Michael Collins, Vera McDonnell, Desmond Fitzgerald, Anna Fitzsimmons Kelly, Unidentified, Brian Fagan, Willie Murray. *Front row, left to right:* Joe Clarke, Barney Mellows, Jenny Mason, Ita Hegarty, Seamus Kavanagh, Unidentified.

Courtesy of Mercier Archives.

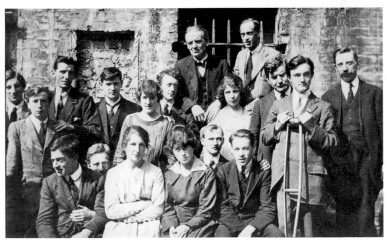

Captain Richard Coleman. From Swords, Richard Coleman was a member of the Fingal Battalion. He took part in the Rising, fighting in the Mendicity Institution under Seán Heuston. He was sentenced to death at his court martial, but the sentence was commuted to penal servitude and he was sent to Lewes Prison in England. He was released as part of the general amnesty in June 1917. He was again arrested in 1917 and went on hunger strike with his commanding officer, Thomas Ashe, in Mountjoy Jail. He was released in 1918. He was arrested once more under the 'German Plot' and was sent to Usk Prison in Wales where in November he fell victim to the flu epidemic. Left untreated he developed pneumonia and died on 7 December 1918. He was twenty-eight years old.

Courtesy of Military Archives Dublin, BMH-CD-188-4-5.

1919-21:
THE WAR OF INDEPENDENCE

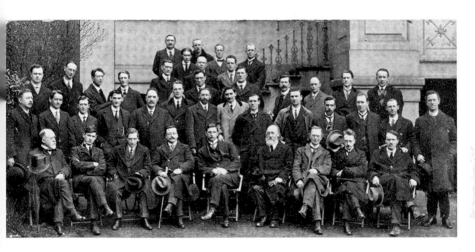

The First Dáil, 10 April 1919, elected in the 1918 General Election. Many of those elected had been in prison at the time, but when this picture was taken the majority had been released.

Front row, left to right: Laurence Ginnell, Michael Collins, Cathal Brugha, Arthur Griffith, Éamon de Valera, Count Plunkett, Eoin MacNeill, W. T. Cosgrave, Ernest Blythe.

Second row, left to right: Patrick J. Moloney, Terence MacSwiney, Richard Mulcahy, Joseph O'Doherty, John O'Mahony, James N. Dolan, Joe McGuinness, Patrick (Paudeen) O'Keefe, Michael Staines, Joe McGrath, Dr Brian Cusack, Liam de Róiste, Michael Colivet, Fr Flanagan.

Third row, left to right: Peter J. Ward, Alasdar MacCába, Desmond Fitzgerald, Joseph Sweeney, Dr Richard Hayes, Con Collins, Pádraic Ó Máille, James O'Mara, Brian O'Higgins, Seamus A. Bourke, Kevin O'Higgins.

Fourth row, left to right: Joseph MacDonagh, Seán MacEntee.

Fifth row, left to right: Piaras Béaslaí, Robert Barton, Peter Paul Galligan.

Sixth row, left to right: Phil Shanahan, Seán Etchingham.

Courtesy of Kilmainham Gaol Archives 19PD-1A13-30.

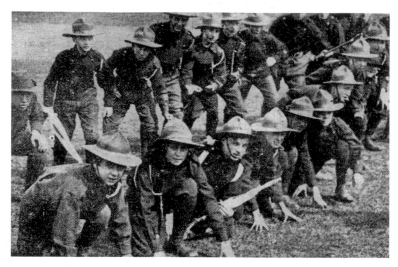

Na Fianna Éireann on training manoeuvres in the Dublin mountains, May 1919. These would include military skills such as despatch carrying, intelligence work, semaphore signalling and rifle practice.
Courtesy of Military Archives Dublin, IE-MA-BMH-P-28-005.

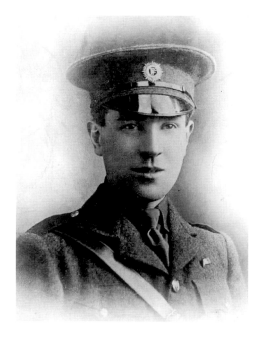

Frank Thornton in Volunteer uniform in 1915. Thornton fought in the Easter Rising and upon the reorganisation of the Volunteers he headed Michael Collins' Intelligence Unit, set up in 1919, which had its headquarters in No. 6 Crow Street.
Courtesy of Military Archives Dublin, IE-MA-BMH-CD-188-1-1.

Tom Cullen, assistant director of Collins' Intelligence Unit, also fought in the Easter Rising. Originally from County Wicklow, he moved to Dublin and joined the Volunteers soon after their inception.

Courtesy of Military Archives Dublin, IE-MA-BMH-CD-188-2-2.

Commandant Paddy Flanagan, C Company, 3rd Battalion, Dublin Brigade. He was a member of the 'Squad', which was set up by Michael Collins in conjunction with his Intelligence Unit. The Unit would provide information to the Squad on members of the British intelligence service and the Squad would then target them for assassination. He later became OC of the Dublin Active Service Unit (ASU), a small unit consisting of specially chosen Volunteers from all the Dublin battalions to carry out daily attacks on the crown forces. He took part in the operations on Bloody Sunday, 21 November 1920, planned by Collins to eradicate the British Secret Service.

Courtesy of James Langton.

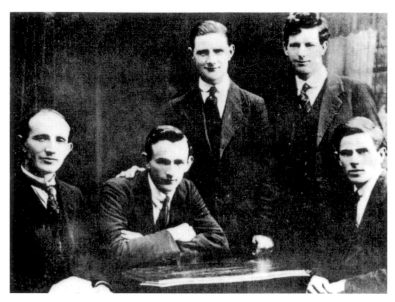

Members of the Squad. *Left to right:* Mick McDonnell, Tom Keogh, Vinny Byrne, Paddy O'Daly and Jim Slattery. The Squad initially consisted of twelve men, but over the course of the War of Independence it grew in size to roughly forty men, although they did not generally operate together in such large numbers.

Courtesy of Mercier Archives.

Members of Collins' intelligence forces. *Left to right:* William Stapleton (Squad), Paddy O'Daly (Squad), Charlie Dalton (Intelligence Unit) and Joe Leonard (Squad).

Courtesy of Chris Dalton.

Charlie Byrne (*left*), 'The Count', with the president of the Provisional Government, W. T. Cosgrave, taken *c*. 1922. Byrne was a member of the Squad during the War of Independence and during the Civil War he was Cosgrave's bodyguard.

Courtesy of James Langton.

Pat McCrae. A member of the ASU during the War of Independence, McCrae assisted 'The Squad' as their driver in many operations, most notably the attempted rescue of Seán MacEoin from Mountjoy Jail in 1921.

Courtesy of Military Archives Dublin, IE-MA-P-22-002.

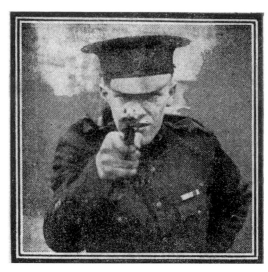

The weaponry of the RIC. An officer of the RIC brandishing a revolver. The RIC, being a semi-military body, had been well equipped up until this time with rifles, bayonets and revolvers. When the force became the prime target of the IRA and began to come under frequent attack, it was decided that it should also be issued with automatic weapons and grenades in an effort to combat the hit-and-run tactics used by the IRA.

Courtesy of Military Archives Dublin, IE-MA-BMH-P-28-002.

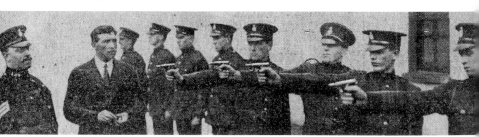

Members of the Dublin Metropolitan Police (DMP) practise using revolvers. The DMP had up to then been an unarmed force, but as the War of Independence escalated this changed. Officers from the Kevin Street depot underwent revolver practice for three hours a day for a week. This training was essential, as this depot was situated in an area known as 'The Dardanelles', in which the 3rd Battalion, Dublin Brigade IRA, operated. This area saw some of the most intense fighting during the war, hence its nickname.

Courtesy of Military Archives Dublin, IE-MA-BMH-P-28-004.

Crown forces raid Harcourt Street. This street was frequently raided during the War of Independence.

Courtesy of Military Archives Dublin, IE-MA-BMH-P-11-001.

Colonel Éamonn (Ned) Broy and his family, 1938. Broy was one of Collins' agents in 'G' Division of the DMP. It was he who passed on the information regarding the 'German Plot' arrests in 1918 and also got Collins into Brunswick Street police station in 1919. Finally coming under suspicion, he was arrested by the British in February 1921. Released after the Truce in July 1921, he was secretary to Collins during the Treaty negotiations. Despite his close friendship with Collins, Broy did not accept the Treaty. He is seen here with his daughters Áine (*being held by her father*), Eilís (*right*) and Máire (*back*).

Courtesy of Áine Broy.

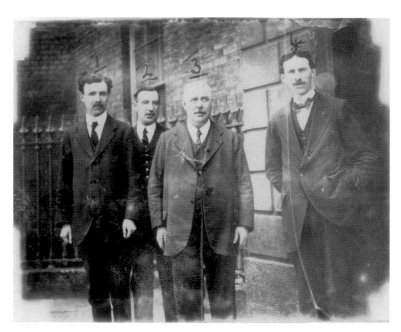

An example of the intelligence gathered by the Intelligence Unit. This is an image of members of the DMP targeted by them, with their names and other relevant information recorded. *Left to right*: 1) Unidentified (dead); 2) Inspector Forrest, G Division; 3) Ex-Superintendent Brian; 4) — Walsh, G Division.

Courtesy of Military Archives Dublin, IE-MA-BMH-CD-227-35-Int-Book-P-6-A-&-B Three G Men.

The Intelligence Unit gathered whatever information they could on anyone they believed was a threat to them, including rank and file DMP constables like Constable P. Carroll of Chapelizod.

Courtesy of Military Archives Dublin, IE-MA-BMH-CD-227-35-Int-Book-P-20-B Constable Carroll.

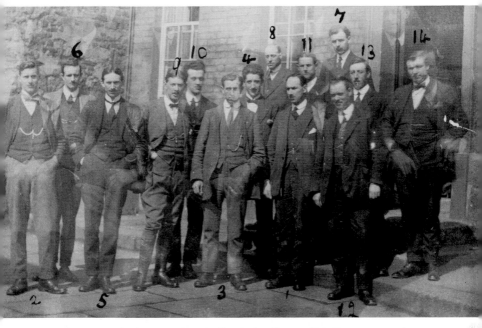

Another image of policemen identified by the Intelligence Unit. These are members of G Division, DMP. 1) — Nixon, 2) F. Thornton, 3) — Wright, 4) — Gibson, 5) — Walsh, 6) — Fennell, 7) Unidentified (dead), 8) — Williams, 9) Sergeant Whelan, 10) — McKeown, 11) Bevan Moncrieff, 12) Sergeant O'Neill, 13) Richard Hall, 14) Patrick Healy.

Courtesy of Military Archives Dublin, IE-MA-BMH-CD-227-35-Int-Book-P-14-C G-Division D.M.P.

A British soldier places a Lewis gun outside the Mansion House, December 1919. It had earlier been subject to a raid by the military, who believed that members of the IRA were holding a meeting. No Volunteers were found in the raid.

Courtesy of Military Archives Dublin, IE-MA-BMH-P-28-010.

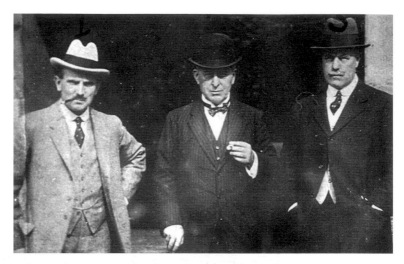

Left to right: Sir Joseph Byrne, RIC inspector-general, Sir Robert Chalmers and Walter Edgeworth-Johnstone, chief commissioner of the DMP. This photograph was among those gathered by IRA GHQ intelligence for identification purposes.

Courtesy of Military Archives Dublin, IE-MA-BMH-CD-227-35-Int-Book-P-22-A Three-Men.

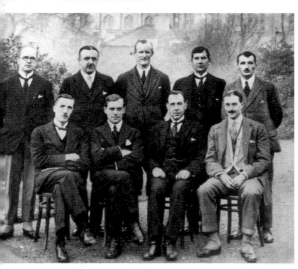

By April 1920 Dublin Castle had become less than effective in its approach to dealing with the IRA. The government realised that new people were needed. This image shows some of the newly appointed Civil Service staff who the government hoped would help turn the tide of the conflict in their favour. *Standing, left to right:* Basil Clarke (director of British propaganda), G. N. Crutchley, L. N. Blake Odgers, M. T. Loughnane, J. P. Fairgrieve. *Seated, left to right:* Geoffrey Whiskard, Alfred Cope (assistant under-secretary for Ireland), John Anderson (under-secretary for Ireland), Mark Sturgis.

Courtesy of Kilmainham Gaol Archives, 19PC-1A55-10.

Sir Ormonde Winter, known as 'The Holy Terror'. Winter was appointed director of British intelligence in April 1920, and is reputed to have been involved in the torture of Ernie O'Malley upon his arrest and detainment in Dublin Castle.

Courtesy of Kilmainham Gaol Archives, 19PC-1A58-26.

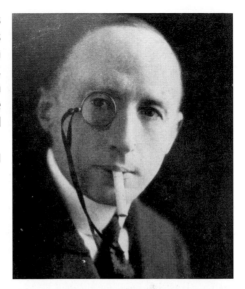

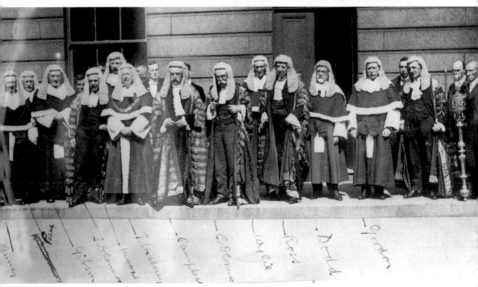

Even members of the judiciary were kept under the watch of Collins' intelligence department. *Left to right:* — Kenny, Unidentified (name illegible), — Gibson, J. O'Connor, — Moore, T. Malone, — Campbell, C. O'Connor, — Wylie, — Ross, — Dodd, — Gordon, Unidentified.

Courtesy of Military Archives Dublin, IE-MA-BMH-CD-227-35-Int-Book-P-23-A Judges.

Captain James J. Walsh seen here on his wedding day. Collins' men were daring in gathering intelligence, in some cases actually attending the weddings of the Secret Service and even the Auxiliary police force. Walsh was a member of the Secret Service operating from both Dublin Castle and Beggars Bush Barracks.

Courtesy of Military Archives Dublin, IE-MA-BMH-CD-227-35-Int-Book-P-29-A-C Captain James J. Walsh.

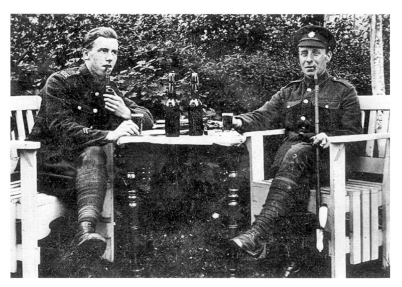

Two British soldiers relax. This photo is another example of the type of intelligence gathered by the IRA, although in this case the men are unidentified.

Courtesy of Kilmainham Gaol Archives, 18PO-1B53-17.

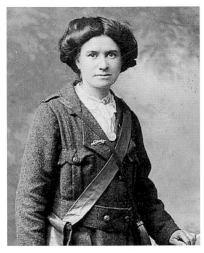

Julia Maher in Cumann na mBan uniform. She ran a shop on George's Quay where she would hide ammunition for the IRA during the War of Independence.

Courtesy of Kilmainham Gaol Archives, 2012.0132.

A lot of information was gathered by Cumann na mBan members, who would befriend men from the crown forces and supply any information learned to the Intelligence Unit. Here Brigid Mahon is seen wearing her Cumann na mBan uniform. She took part in the Easter Rising carrying despatches between Boland's Mills, the GPO and the College of Surgeons. She took the anti-Treaty side during the Civil War, and carried out first aid duties in the Gresham Hotel and later St Stephen's Green during the fighting in Dublin.

Courtesy of Stephen Byrne.

Elizabeth O'Driscoll (née Maguire) in her Cumann na mBan nurse's uniform. During the War of Independence she was involved in intelligence work. She opposed the Treaty and when the Civil War began she was with the anti-Treaty garrison in Findlater's in O'Connell Street. She later married Daniel O'Driscoll, a native of Cork. He was a member of the 3rd Engineers, 5th Battalion, Dublin Brigade. He also took the anti-Treaty side in the Civil War.

Courtesy of Mick Doyle and Richard O'Driscoll.

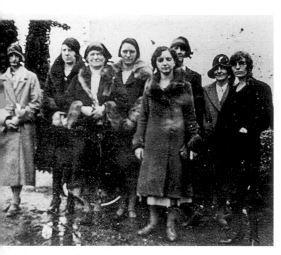

Unidentified members of Cumann na mBan. The intelligence work of the women of Cumann na mBan during the War of Independence was vital to the success of the fight for independence.

Courtesy of Kilmainham Gaol Archives, 17PC-1A41-30g.

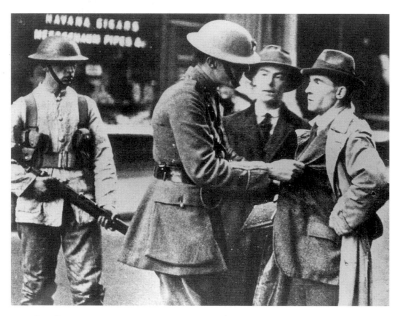

A civilian being searched by the military. This photograph is part of a series that was taken by the American Commission on the Conditions in Ireland in 1920. The commission came to Ireland to investigate what was happening there, and compiled a report. In response the British government commissioned its own report. The two reports differed substantially in their findings.

Courtesy of Kilmainham Gaol Archives, 19PC-1A46-25.

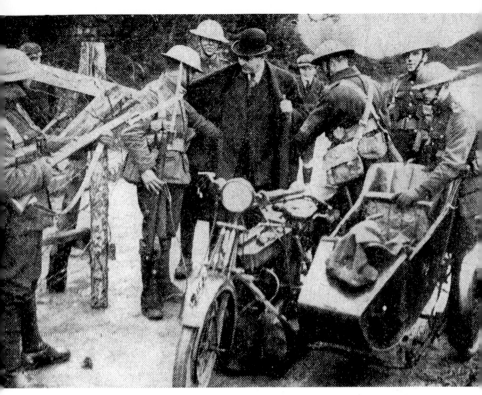

Fearful that a repeat of the events of Easter 1916 would take place, in April 1920 the military surrounded the city, stopping and searching anyone who wished to enter. This did not, however, prevent the IRA from destroying a number of Income Tax offices, a policy that would continue throughout the War of Independence in an effort to disrupt British bureaucracy and make governing the country harder.

Courtesy of Military Archives Dublin, IE-MA-BMH-P-28-008.

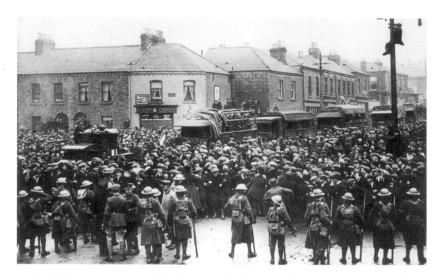

The British Army try to hold back the crowds demonstrating outside Mountjoy Jail, possibly at the time of the hunger strike in April 1920. Members of the IRA who were imprisoned there were campaigning for the right to be treated as political prisoners, not common criminals. They later changed their demands to release from prison.

Courtesy of Mercier Archives.

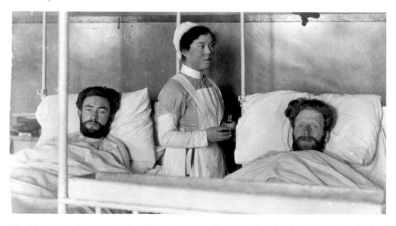

The Mountjoy hunger strike. This photograph was taken in the Mater Hospital in April 1920 after the hunger strike ended. It shows Maurice Crowe (*left*), leader of the hunger strike, and a member of the 3rd Tipperary Brigade IRA. Michael Carolan from Belfast is on the right.

Courtesy of Military Archives Dublin, IE-MA-BMH-CD-208-2-11.

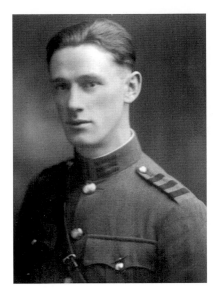

Joe O'Reilly, originally from Bantry, Cork, fought in the Rising and was sent to Frongoch. His devotion to Collins knew no bounds, and throughout the War of Independence and subsequent Civil War he was at Collins' beck and call, carrying out highly secretive work.

Courtesy of James Langton.

Brigadier-General F. P. Crozier was appointed commander of the Auxiliaries in July 1920. Although a firm believer in dealing with the IRA harshly, he did not agree with the methods employed by the men he was in charge of. When he was made aware of an attempt on the life of the Catholic bishop of Killaloe planned by the Auxiliaries, he tried to alert the bishop by sending a message, but it was not delivered. (Luckily for the bishop he was in Dublin on the day of the planned attack.) He was also responsible for saving the life of Frank Teeling, who having taken part in the op-

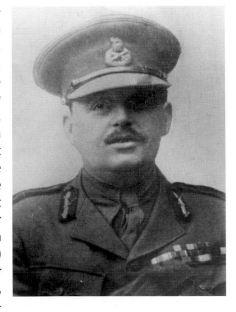

erations on Bloody Sunday at 22 Lower Mount Street was about to be executed by an Auxiliary. He resigned his command in February 1921 after a number of cadets he had discharged from the Auxiliaries were reinstated.

Courtesy of Mercier Archives.

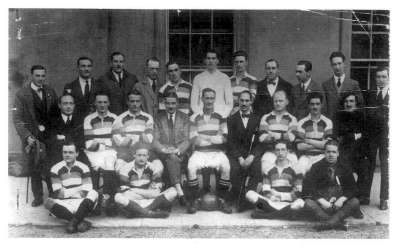

Members of F Company, Auxiliaries, football team. F Company of the Auxiliary police force operated from Dublin Castle and was very enthusiastic in its efforts to capture the IRA.

Courtesy of Military Archives Dublin, IE-MA-BMH-P-10-001.

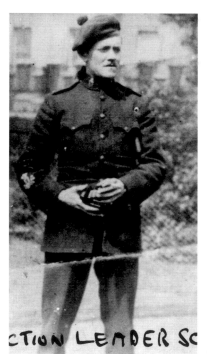

Section Leader Schofield, F Company, Auxiliaries.

Courtesy of Military Archives Dublin, IE-MA-BMH-CD-227-35-Int-Book-P-40-B-C Section Leader Schofield.

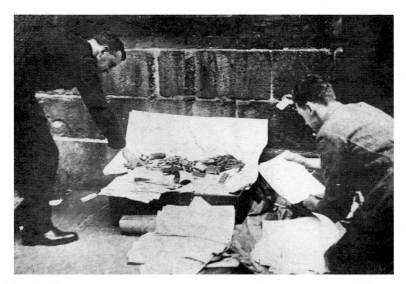

British intelligence officers examine a cache of arms and documents.
Courtesy of Mercier Archives.

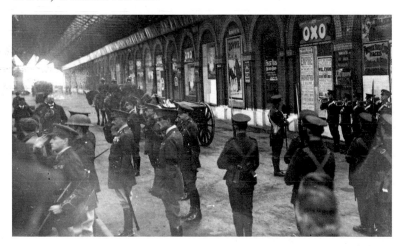

The coffin of Major Smyth is saluted as it is boarded onto a train in Amiens Street (now Connolly) Station en route to Banbridge. Smyth believed that his brother, RIC Commissioner Bryce-Ferguson Smyth had been killed by Dan Breen. Determined to catch Breen he traced him and Seán Treacy to 'Fernside', the house of Professor Carolan in Drumcondra, on 12 October 1920, but in the raid on the house Smyth was shot dead by Breen. Professor Carolan was deliberately killed in response.
Courtesy of the National Library of Ireland.

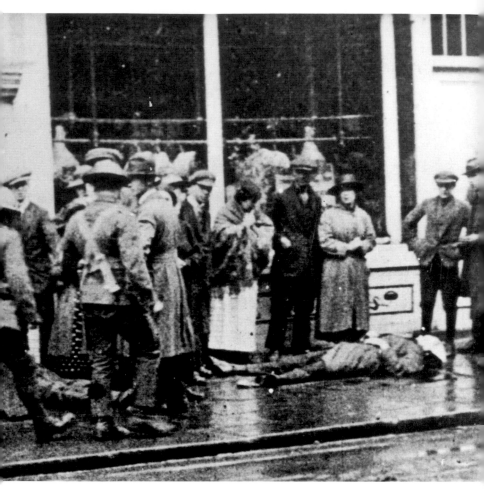

The death of Seán Treacy, 14 October 1920. Treacy, together with his comrade Dan Breen, were two of the most wanted men in Ireland. Having organised the ambush at Soloheadbeg in January 1919, considered the first action of the War of Independence, in which two RIC men were killed, Treacy and Breen had been on the run since that time. Together with Seamus Robinson and Seán Hogan, 'The Big Four', as they were known, often took part in operations with the Squad in Dublin. However, by October 1920 time was running out for them. Aided by police from Tipperary, British intelligence forces were closing in on them, finally tracing Treacy to the Republican Outfitters in Talbot Street. Treacy was shot and killed while trying to escape. He was twenty-five years old and due to be married.

Courtesy of Mercier Archives.

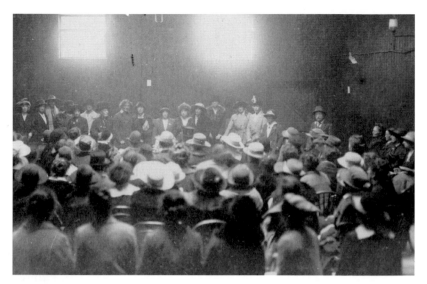

Cumann na mBan Convention, October 1920. This meeting was to be held in the Mansion House, but with that premises under constant watch by the authorities, the priests from Whitefriar Street offered them a room at the back of the church to hold the meeting. They had to enter via the church so there was no suspicion. *Left to right, facing camera:* Mabel Fitzgerald, Mary MacSwiney, Louise Gavan Duffy, Miss O'Rahilly, Mrs Áine O'Rahilly, Máire O'Reilly, Mrs Pearse, Countess Markievicz, Mrs Kathleen Clarke, Mrs Áine Ceannt, Nancy Wyse Power, Madge Daly, Miss Elizabeth Bloxam, Mrs Wyse Power, Miss Fanny Sullivan, Lily Brennan. Many of these women were on the organisation's Executive.

Courtesy of Military Archives Dublin, BMH-CD-216-3.

Kevin Barry, who was executed on 1 November 1920 for his part in a raid for arms in Church Street, in which a British soldier was killed. He was a student of Belvedere College. Despite many pleas to the British government for clemency, he was hanged in Mountjoy Jail. He was eighteen years old. His death mask can be seen today in St Catherine's Church, Meath Street.

Courtesy of Kilmainham Gaol Archives, 19PC-1A46-17.

Albert Rutherford, C Company, 3rd Battalion, Dublin Brigade, took part in the operations on 'Bloody Sunday', 21 November 1920, when Collins ordered the assassinations of British Secret Service men throughout the city. In all, fourteen men were killed. Reprisals for the operation by the British were swift and brutal.

Courtesy of Kilmainham Gaol Archives, 2010.0215.

As a result of the assassinations that morning, members of the Auxiliaries and the military made their way to Croke Park, where thousands of people had gathered to see the Gaelic football match between Tipperary and Dublin. They entered the grounds and opened fire on the crowds. Thirteen people were killed, including Tom Hogan, seen here, from Kilmallock and Michael Hogan, a Tipperary player; upwards of sixty people were wounded.

Courtesy of Mercier Archives.

This photograph of Croke Park was taken on 22 November, the day after the Bloody Sunday shootings took place.

Courtesy of the National Library of Ireland.

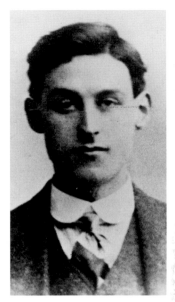

Dick McKee, OC Dublin Brigade. McKee, as commanding officer of the Dublin Brigade, was instrumental in planning the operations on Bloody Sunday with Collins and his second-in-command Peadar Clancy. Both McKee and Clancy were arrested on the night of Saturday 20 November in Gloucester Street. Unknown to them they were being watched by John 'Shankers' Ryan, a local man who was an informer and alerted the military to their whereabouts. Together with Conor Clune, they were detained in Dublin Castle. They were beaten and tortured, then killed 'while trying to escape' on 21 November.
Courtesy of Military Archives Dublin, IE-MA-BMH-P-13-001.

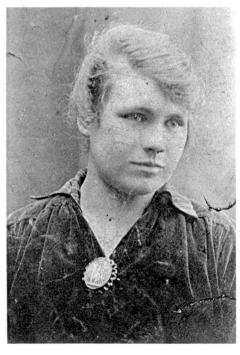

May Gibney. A member of Cumann na mBan, Gibney was in the GPO during the Rising. She was engaged to Dick McKee.
Courtesy of Kilmainham Gaol Archives, 20PC-1A22-16a.

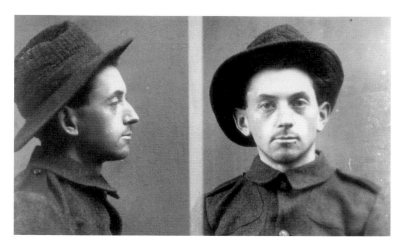

Peadar Clancy, second-in-command to Dick McKee, fought in Church Street in the Easter Rising. He was also one of the main protagonists in the Mountjoy hunger strike in April 1920 and was killed along with McKee in Dublin Castle on Bloody Sunday.
Courtesy of Kilmainham Gaol Archives, 17PO-1A22-20.

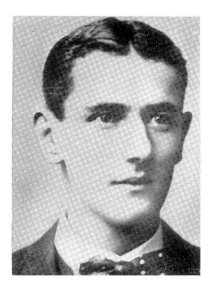

Conor Clune, from Raheen, County Clare, had travelled to Dublin on Gaelic League business. He went to Vaughan's Hotel, Parnell Square, where he was to meet fellow Gaelic Leaguer and editor of *An tÓglách* Piaras Béaslaí. Vaughan's was well known to the authorities as a location used by the IRA and was raided on the night of 20 November. Unable to provide a satisfactory alibi to the authorities, he was arrested and taken to Dublin Castle. Although he had nothing to do with Bloody Sunday, he was tortured and killed along with Dick McKee and Peadar Clancy.
Author's collection.

Madam Becky Cooper, a well-known madam in the 'Monto', the famous red-light district just a stone's throw away from O'Connell Street. Her premises were frequently visited by the British, where they gathered much intelligence on the IRA. It was her brother John 'Shankers' Ryan who alerted the military to the whereabouts of McKee and Clancy. 'Shankers' Ryan suffered a similar fate to the men he informed on when, in February 1921, members of the Squad, on the orders of Collins, assassinated him.

Courtesy of Terry Fagan and the Inner City Folklore Project.

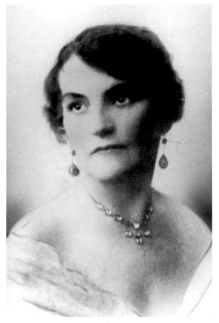

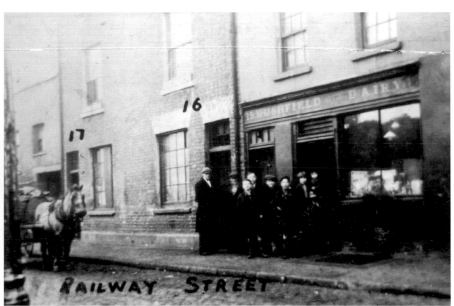

16 Railway Street, the home of John 'Shankers' Ryan.

Courtesy of Terry Fagan and the Inner City Folklore Project.

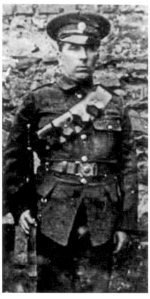

Volunteer Seán Fitzpatrick. This photograph was taken in the back yard of his house at 36 Lower Gloucester Street, now Seán MacDermott Street. It was in this house that Dick McKee and Peadar Clancy were arrested on the night of 20 November.

Courtesy of Terry Fagan and the Inner City Folklore Project.

Auxiliaries raid Liberty Hall, 22 November. After Bloody Sunday there were massive swoops carried out by the military, Auxiliaries and Black and Tans to try to arrest anyone suspected of being involved in the previous day's events. Liberty Hall was well known as a place where activists met. The two men on the left are Thomas Johnson and Thomas Farren.

Courtesy of Military Archives Dublin, IE-MA-BMH-P-37-001.

Members of the Irish Peace Mission at Mountjoy Jail. After Bloody Sunday, British Prime Minister David Lloyd George and his government reassessed the situation in Ireland and arranged for a peace delegation to go to Ireland and talk to members of the Nationalist and Republican bodies. The aim was to seek terms of negotiation that could possibly lead to the ending of the conflict. As many of the Nationalist TDs were in prison it was necessary for the meetings to be held there.

Courtesy of Mercier Archives.

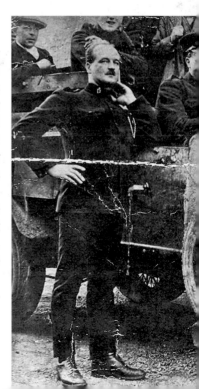

Eugene Igoe, an RIC head constable. Originally from County Mayo, Igoe was transferred to Dublin in January 1921 on the orders of Colonel Winters in his bid to destroy the IRA. Igoe had already shown he was capable in his pursuit of the IRA and together with men he personally recruited, known as the Igoe Gang, they were more than a match for the Volunteers. They patrolled the railway stations observing the passengers and would patrol the city. Like the Squad they wore civilian clothes and were well armed. Upon seeing a suspect they would act quickly, never drawing attention to themselves. Although there were numerous attempts by the Squad to kill Igoe, they never succeeded.

Courtesy of Kilmainham Gaol Archives, 19PO-1A32-03.

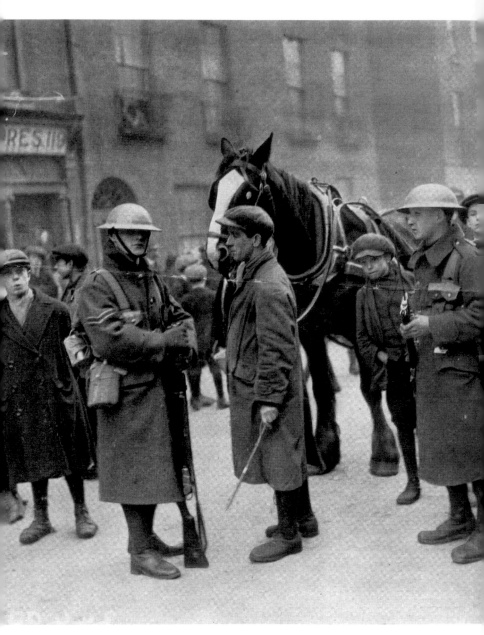

In a typical scene from Dublin and, indeed, throughout the country during the War of Independence, the military conduct a routine search of civilians.

Courtesy of Military Archives Dublin, IE-MA-PC-768 Dublin Street Round Up.

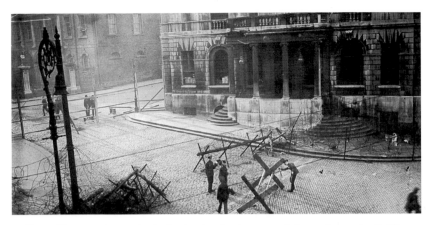

The military construct barbed wire barricades around the entrance to Dublin Castle, January 1921.

Courtesy of Mercier Archives.

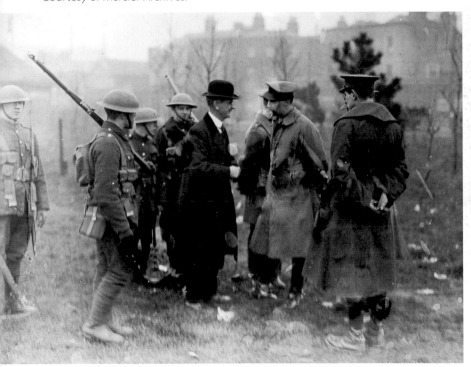

British soldiers question a civilian during a raid in a park, Dublin.

Courtesy of Mercier Archives.

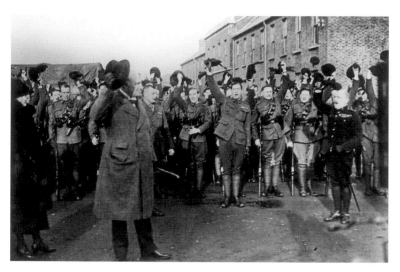

The Auxiliaries cheer Sir Hamar Greenwood, last chief secretary of Ireland, January 1921.

Courtesy of Mercier Archives.

Volunteer Frank Teeling. Involved in the operations on Bloody Sunday, he was present at 22 Lower Mount Street and was wounded when trying to leave, suffering horrific injuries to his abdomen. He was saved by General Crozier, who saw that Teeling was about to be executed there and then, and stepped in. Instead Teeling was arrested and taken to hospital. He was later transferred to Kilmainham Gaol where he would await trial for his involvement in Bloody Sunday. However, before he could stand trial, along with Ernie O'Malley and Simon Donnelly, he escaped from Kilmainham on 14 February 1921.

Courtesy of Kilmainham Gaol Archives, 19PC-1K44-25.

A mugshot of Ernie O'Malley taken after his arrest. Wanted for some time by the authorities, O'Malley was eventually arrested in Kilkenny in December 1920. As an organiser for GHQ he led many attacks on RIC barracks around the country. He was brought to Dublin Castle and interrogated by Captain King. Calling himself Bernard Stewart and refusing to talk, he was transferred to Kilmainham Gaol and successfully escaped with Teeling and Donnelly.

Courtesy of Kilmainham Gaol Archives, 19PC-1A54-21a.

Simon Donnelly at the famous 'escape gate', Kilmainham Gaol. Captain of C Company, 3rd Battalion, Dublin Brigade, and later chief of the Irish Republican Police, Donnelly had fought in the Easter Rising. He was arrested near Dublin Castle on 10 February 1921 and taken to Kilmainham. In the original escape plans it was Teeling, O'Malley and Patrick Moran who were meant to get out. Moran was awaiting trial for his involvement in Bloody Sunday. The first attempt failed because the bolt cutters that had been smuggled into the jail by the

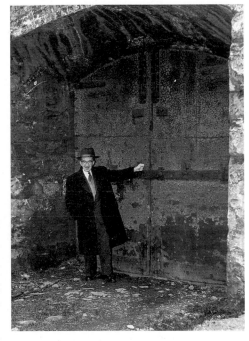

guards broke. Moran refused to go on the next attempt and Donnelly went in his place. The three men simply walked out the gate and were free.

Courtesy of Kilmainham Gaol Archives, 21PC-3K11-01.

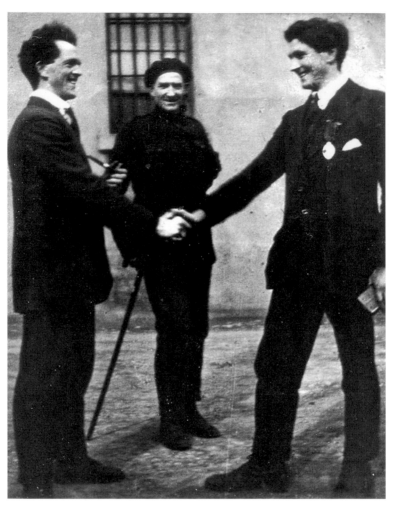

Patrick Moran (*left*) and Thomas Whelan (*right*) before their execution. Patrick Moran was originally from Roscommon and Whelan was from Connemara. Both moved to Dublin and joined the Dublin Brigade of the IRA. Moran was in the 2nd Battalion, while Whelan was a member of the 3rd. Both men were arrested after the events of Bloody Sunday and were later put on trial in City Hall in February 1921. They were found guilty and subsequently hanged in Mountjoy Jail on 14 March 1921. Moran was supposed to escape with O'Malley and Teeling, but was convinced that he would be acquitted at his trial. Patrick Moran was thirty-three years old. Thomas Whelan was twenty-two.

Courtesy of Kilmainham Gaol Archives, 19PO-1A33-22.

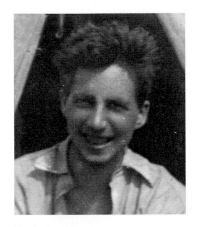

Frank Flood

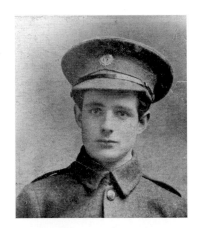

Bernard Ryan

Patrick Doyle

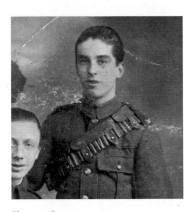

Thomas Bryan

All four of these men were executed for their involvement in the 'Drumcondra Ambush', which took place on 21 January 1921. Led by Flood, lieutenant of H Company, 1st Battalion, a group of twelve men ambushed a tender full of RIC at the Tolka Bridge. However, reinforcements quickly arrived and the attack failed. Flood was wounded in the attack. Arrested, the men were tried in February, found guilty of high treason and levying war against the King and sentenced to death. All four were executed in Mountjoy Jail on 14 March. Frank Flood was only nineteen years old, Patrick Doyle, twenty-nine, Bernard Ryan, twenty, and Thomas Bryan, twenty-two.

Courtesy of Kilmainham Gaol: Frank Flood – 19PO-1A26-28; Bernard Ryan – 19PD-1A14-02; Patrick Doyle – 2011.0469a; Thomas Bryan – 19PO-1A32-06.

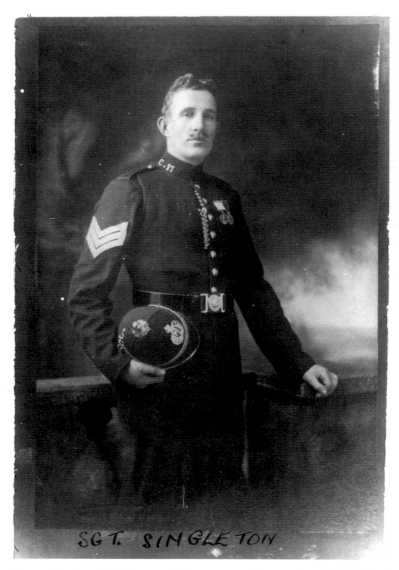

SGT. SINGLETON

Sergeant Singleton DMP. Sergeant Singleton gave evidence at the trial of Flood and his men, as he had seen them at the bridge and had alerted the military, which led to their arrest, thus making him a prime target for the Squad. Realising he was in danger he was sent to England.

Courtesy of Military Archives Dublin, IE-MA-BMH-CD-227-35-Int-Book-P-31-A-C Sgt-Singleton.

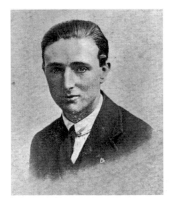

Volunteer Leo Fitzgerald, B Company, 3rd Battalion, Dublin Brigade, was killed in action at the Battle of Brunswick Street which took place on the night of 14 March 1921. The IRA had its headquarters in 144 Brunswick Street and the area was regularly patrolled. Two lorry loads of Auxiliaries, together with an armoured car, were driving towards the building intending to raid it, when the IRA opened fire on them. Members of B Company fiercely fought the crown forces, but in the end, after hours of fighting, and outnumbered and outgunned, the Volunteers were forced to retreat. Besides Leo Fitzgerald, Volunteer Bernard O'Hanlon was also killed. British losses were two killed and five wounded.

Courtesy of Kilmainham Gaol Archives, 19PD-1A17-27.

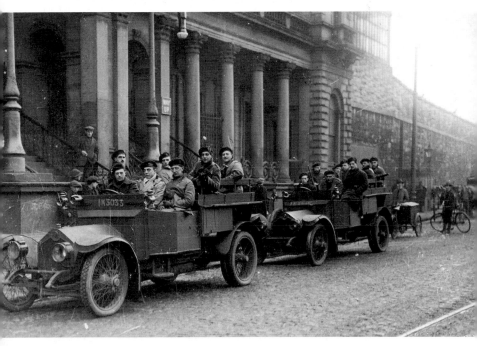

Two lorry loads of Black and Tans and Auxiliaries prepare to leave Amiens Street Station on a routine search of the city.

Courtesy of the National Library of Ireland.

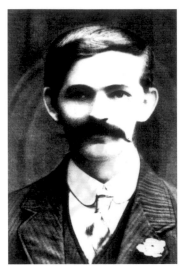

Volunteer Thomas Traynor was arrested at the Battle of Brunswick Street along with Jack Donnelly. Originally from Carlow, Traynor moved to Dublin and opened a shoemaker's shop. He fought in Boland's Mills during the Rising and was subsequently interned. Upon his release he rejoined the Dublin Brigade. He was interrogated by the Igoe Gang after his arrest. Tried by court martial, he was hanged in Mountjoy Jail on 25 April.

Courtesy of Mercier Archives.

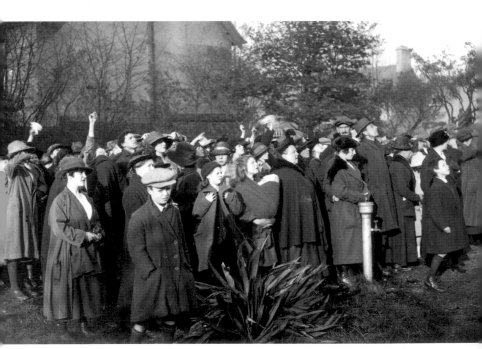

Crowds gather outside Mountjoy Jail on the morning of Thomas Traynor's execution.

Courtesy of Mercier Archives.

Temporary Constable T. Redmond, Auxiliary RIC, Beggars Bush, was shot dead by the IRA in May. His body was found at Frankfurt Cottages near Amiens Street. He had been granted permission to be absent from duty – a pass was found on his body.

Courtesy of Military Archives Dublin, IE-MA-BMH-CD-227-35-Int-Book-P-31-C.

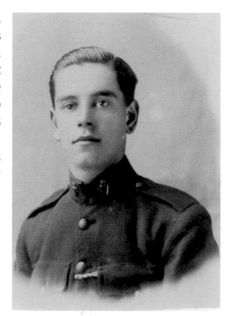

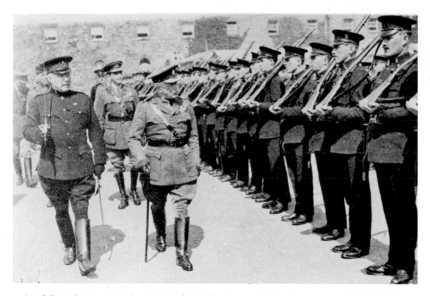

Lord French inspects the RIC and Auxiliaries on his last engagement before he left Ireland in May 1921. Behind him is General Tudor, chief of police in Ireland 1920–21.

Courtesy of Kilmainham Gaol Archives, 19PC-1A57-13.

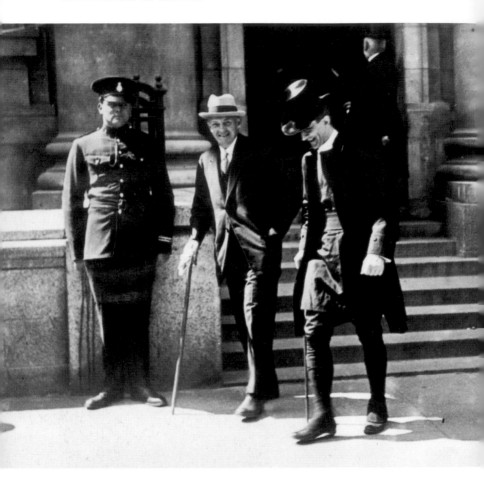

A DMP constable on duty outside the Southern Parliament. Following the partition of Ireland two parliaments had been officially established, one in the south and one in the north. The Southern Parliament met on 28 June 1921, but could not function as Sinn Féin boycotted it, refusing to recognise its existence. Dr John Gregg (*right*), the Church of Ireland Archbishop of Dublin, was on the Privy Council of this parliament.

Courtesy of Mercier Archives.

25 MAY 1921:

THE BURNING OF THE CUSTOM HOUSE

On 25 May 1921, the IRA's Dublin Brigade stormed the Custom House and proceeded to destroy the building. The building had long been a target in the eyes of the IRA, which as far back as 1918 wished to destroy it and more importantly its contents, as it was the administrative heart of the government. The aim of the operation was not only to destroy the records housed there, but also to bring international attention to what was happening in Ireland. Both of those objectives were achieved.

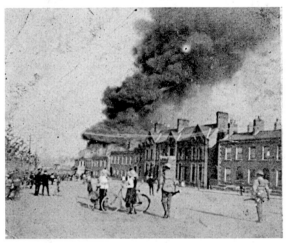

Smoke billows from the burning building.

Courtesy of Kilmainham Gaol Archives, 19PO-1A32-02c.

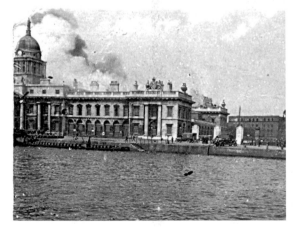

A view of the building from the south side of the Liffey.

Courtesy of Kilmainham Gaol Archives, 19PO-1A32-02d.

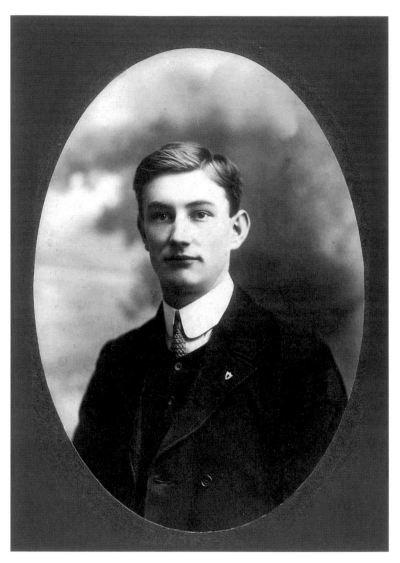

Oscar Traynor. After the death of Dick McKee in November 1920, Oscar Traynor became OC of the Dublin Brigade. He had fought in the Easter Rising and after his release from internment rejoined his comrades in the 2nd Battalion. He personally examined the building to see if it was a viable target, and upon deciding that it was he insisted that the actual destruction of the building would be carried out by the 2nd Battalion, his former battalion. This photo was taken *c*. 1911.
Courtesy of Pearse Cafferky.

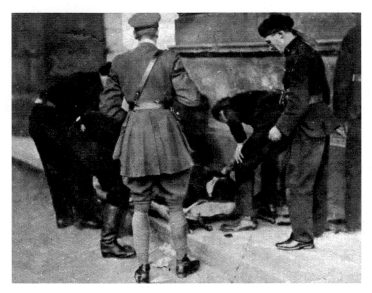

Although the operation was supposed to take just twenty-five minutes, all did not go according to plan inside the building and before long it was surrounded by the military and the Auxiliaries while the Volunteers were still inside. Volunteers covering the building outside opened fire and a full-scale battle broke out. Here a wounded Auxiliary lies on the footpath after the battle.

Courtesy of Military Archives Dublin, IE-BMH-CD-188-4-6A.

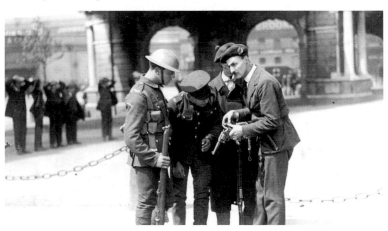

Soldiers and Auxiliaries reload their weapons. In the background can be seen a number of Volunteers after their capture, hands held over their heads.

Courtesy of Kilmainham Gaol Archives, 19PC-1B51-03.

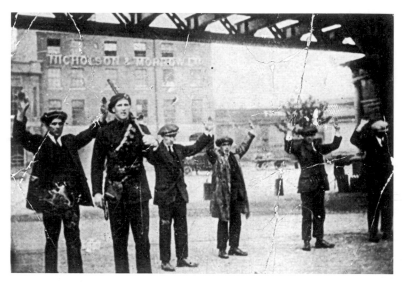

Captured Volunteers under guard underneath the Loop Line Bridge. Volunteer Richard McGrath, 2nd Battalion, Dublin Brigade, is second from right.

Courtesy of Kilmainham Gaol Archives, 2010.0061.

British soldiers load the body of a man killed during the burning of the Custom House. In the confusion four civilians were killed. Casualties for the Volunteers were five dead, a number wounded and at least ninety men captured. The Auxiliary casualties were five wounded.

Courtesy of Mercier Archives.

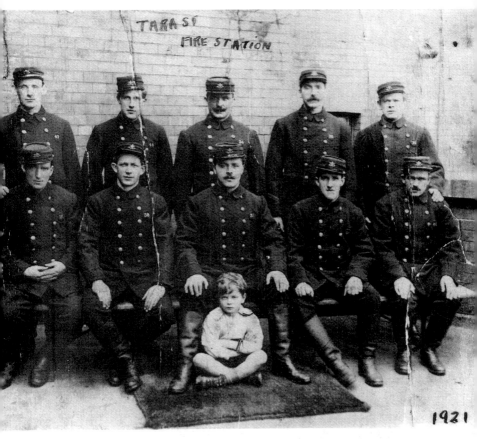

Members of the Dublin Fire Brigade, Tara Street. During the operation fire stations all over the city were taken over by the Volunteers and held for the duration to prevent the Fire Brigade from putting out the fire in the Custom House. However, the Dublin Fire Brigade played an important role in the burning of the Custom House, as unknown to the authorities many firemen were either Volunteers or Citizen Army men and were quite happy to do what they could to facilitate the burning. When they did arrive at the scene, they were less than enthusiastic in their efforts to quell the blaze. When inside the building some even set fire to rooms that had not been reached by the Volunteers and they also helped a number of Volunteers who were trapped inside the building escape.

Courtesy of Las Fallon.

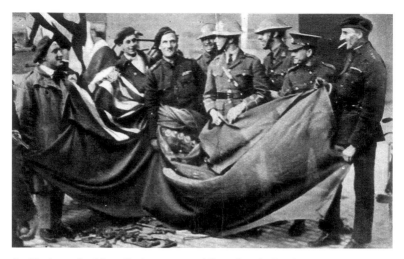

Auxiliaries and soldiers display a captured flag after the battle.
Courtesy of Military Archives Dublin, IE-BMH-CD-188-4-6b.

Members of the 'Custom House Fire Brigade'. These head shots are part of a photo album made in Kilmainham Gaol between July and December 1921. It contains sixty-eight photographs of Volunteers of the 2nd Battalion who took part in the operation and later called themselves 'The Custom House Fire Brigade'. The photographs were taken with a handmade camera that was smuggled into the prison. The album belonged to Cyril Daly, who had taken part in the operation.
Courtesy of Kilmainham Gaol Archives, 2010.0123.

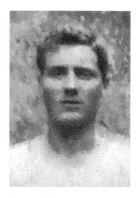 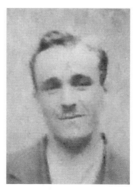

Frank Bolster Christopher Byrne William Donegan

Phil Flynn

John Foy

John Muldowney

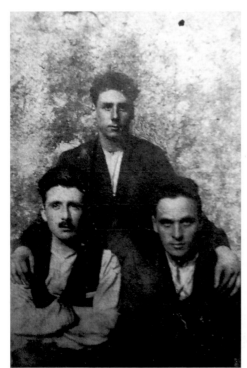

Left to right: Unidentified, Michael Lane, Ed Lane.
Courtesy of Frank Lane.

Thomas O'Flanagan

Jack Nolan

1921-22:
TRUCE AND TREATY

With the conflict showing no signs of ending any time soon it was decided by the British government that another attempt was needed to try to end the war. This led to talks between British and Irish delegates which culminated in the Truce of July 1921, which effectively ended the War of Independence.

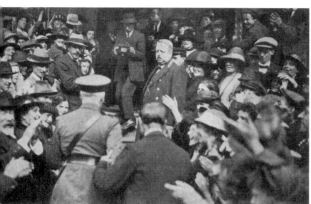

General Macready enters the Mansion House for the Irish Peace Conference to discuss calling a truce in July 1921, accompanied by the Lord Mayor of Dublin, Laurence O'Neill.
Courtesy of Military Archives Dublin, IE-BMH-CD-250-5-5.

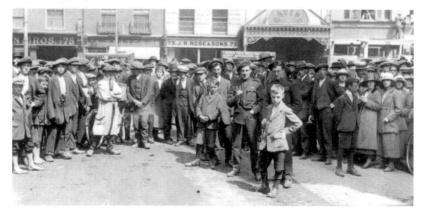

Crowds gather outside the entrance gate to Dublin Castle on the day the Truce came into effect, 11 July.
Courtesy of Kilmainham Gaol Archives, 19PC-1A57-16.

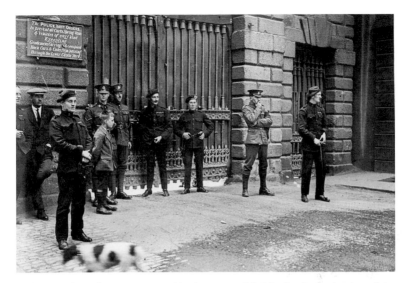

Soldiers and Auxiliaries wait outside the gates of Dublin Castle on the day of the Truce.

Courtesy of Mercier Archives.

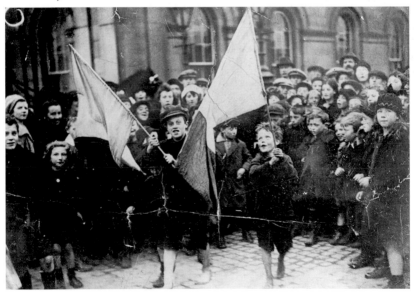

Two boys wave the Tricolour proudly, probably on or just after the day the Truce came into effect.

Courtesy of Kilmainham Gaol Archives, 19PO-1A33-24.

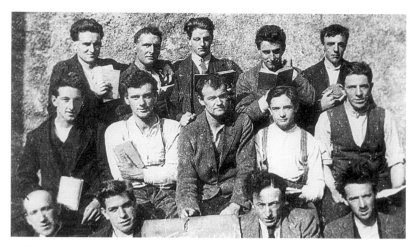

While negotiations for a treaty between Ireland and Britain were going on, many IRA men were still incarcerated in Kilmainham Gaol. The men had the makings of cameras smuggled in and during the Truce took many photographs. Prior to the Truce the men were not given political status and the regime was strict, so taking such group shots would have been impossible. But once the Truce was declared they were allowed freedom of association. *Front row, left to right:* Jim Gibbons, Michael Murphy, Stephen O'Neill, Anthony Flynn. *Middle row, left to right:* Eddie (Ned) Fogarty, Myles Duffy, Paddy MacAleese, Richard McGrath, Jack Nolan. *Back row, left to right:* Unidentified, Robert Halpin, F. L. Waldron, Cyril Daly, John Doyle.
Courtesy of Kilmainham Gaol Archives, 19PC-1A54-08a.

Students of an Irish language class in Kilmainham.
Left to right: Patrick McCourt, Daniel Finlayson, Michael Murphy, Unidentified, William Donegan, Unidentified, John Grace, Paddy Lawson.
Courtesy of Kilmainham Gaol Archives, 19PC-1A54-09d.

More internees pose for the camera. *Front row:* Unidentified. *Middle row, left to right:* Thomas Rigney, Cyril Daly, James Goggins, Charles McCabe. *Back row, left to right:* Unidentified, Robert Halpin, Eddie (Ned) Fogarty. Charles McCabe, seen holding a handkerchief to his mouth, had just undergone dental work. He refused to sign a form stating that if he was let out, under escort, to the dentist to have his teeth out that he would not try to escape. As a result the work was carried out in Kilmainham Gaol without anaesthetic.
Courtesy of Kilmainham Gaol Archives, 19PC-1A54-09c.

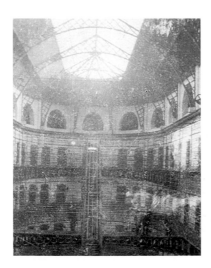

The East Wing, Kilmainham Gaol. This is where members of the IRA were held after the Truce was declared. Up to this point British soldiers were billeted in this part of the prison. Before this the prisoners were held in the gaol's old West Wing.
Courtesy of Kilmainham Gaol Archives, 19PC-1A54-08f.

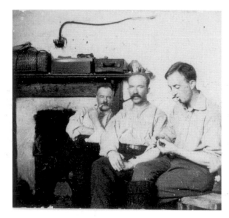

Relaxing in Kilmainham Gaol. *Left to right*: P. Byrne, Christy Byrne, George Plunkett. Christy Byrne was OC of the 4th Battalion, Dublin Brigade. While imprisoned in Kilmainham he was elected OC of the prisoners and it was his duty to liaise with the governor regarding the men's needs.
Courtesy of Kilmainham Gaol Archives, 19PO-1A32-01.

Volunteers pose for the camera. Tony Woods (*left*) and George Dwyer. Tony Woods was a member of the 3rd Battalion and George Dwyer was a member of F Company, 4th Battalion.
Courtesy of Kilmainham Gaol Archives, 19PO-1A33-25.

Relaxing in the exercise yard in Kilmainham Gaol. This photograph was taken at the back of the East Wing of Kilmainham. *Left to right*: Unidentified, John Clarke (holding dog), Christy Byrne.
Courtesy of Kilmainham Gaol Archives, 2011.0462.

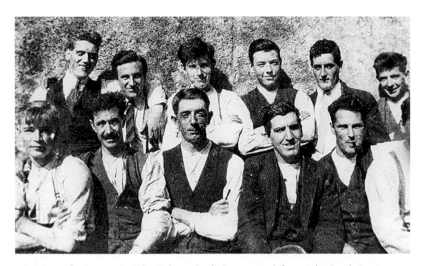

A group of prisoners in Kilmainham Gaol. *Front row, left to right:* Frank Brennan, Frank Carberry, James Goggins, Michael Fleming, Unidentified. *Back row, left to right:* Unidentified, Unidentified, Unidentified, William Donegan, Unidentified, R. J. Doyle.

Courtesy of Kilmainham Gaol Archives, 19PC-1A54-08c.

The Volunteers role-play. *Left:* three Volunteers dressed up as Auxiliaries interrogating a Volunteer. George Dwyer is on the right, smoking a cigarette. *Right:* Volunteers dressed as Auxiliaries search a suspect.

Courtesy of Kilmainham Gaol Archives, 20PC-3N25-05, 2011.0465.

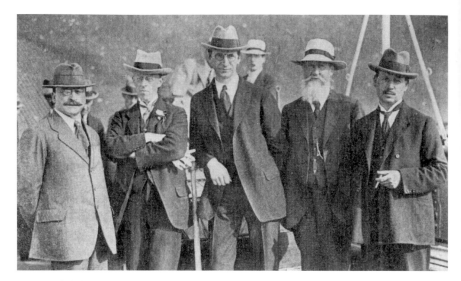

Irish delegates at Dun Laoghaire about to leave for London, 14 July. The delegation, headed by Éamon de Valera, was travelling to London on the invitation of Lloyd George to discuss the possibility of a lasting settlement. *Left to right*: Arthur Griffith, Robert Barton, de Valera, Count Plunkett and Laurence O'Neill.
Courtesy of Military Archives Dublin, IE-BMH-CD-250-5-5.

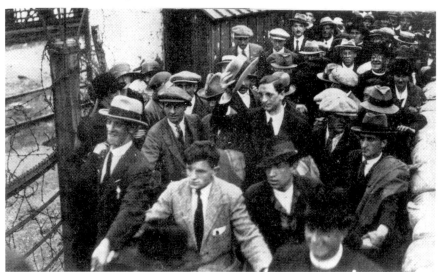

De Valera's return to Ireland from his talks in London with Lloyd George.
Courtesy of Kilmainham Gaol Archives, 19PC-1A25-23.

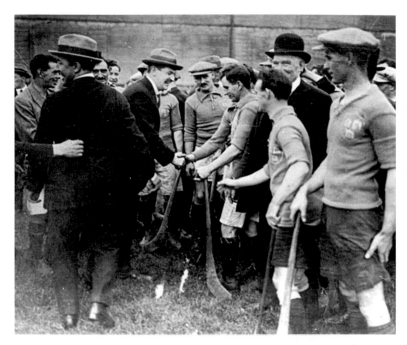

Michael Collins and Harry Boland (*left, looking left*) relaxing during the Truce at a hurling match in Croke Park.

Courtesy of Kilmainham Gaol Archives, 19PC-1B51-04.

'Throwing in the ball': General Seán MacEoin (*right*), the 'Blacksmith of Ballinalee', at a hurling match in Croke Park.

Courtesy of Military Archives Dublin, IE-BMH-CD-308-3-4.

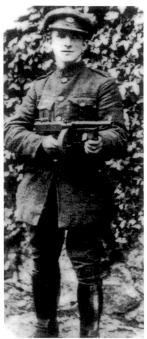

Edward 'Nipper' Byrne. A member of C Company 2nd Battalion, Dublin Brigade, and the ASU, 'Nipper' had taken part in many engagements throughout the War of Independence. Here he poses with one of the few Thompson guns that were smuggled into the country just before the war ended. The IRA had ordered 500 Thompson sub-machine guns from America, but the guns were discovered and impounded by American customs officials, Department of Justice agents and members of the New Jersey police force. The IRA were successful in smuggling more into Ireland during the Truce.

Courtesy of Catherine Long.

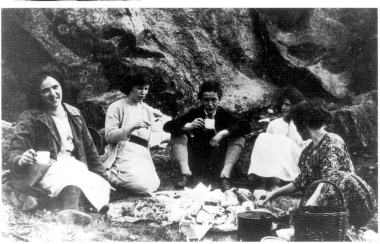

As a result of the Truce it was now safe for the Volunteers and those who had been involved to move about freely, and actually enjoy a sense of normality. Here some members of Cumann na mBan enjoy a picnic in the Dublin Mountains. Ita O'Gorman and Mary Coyle are amongst the group.

Courtesy of Kilmainham Gaol Archives, 19PC-1B52-17.

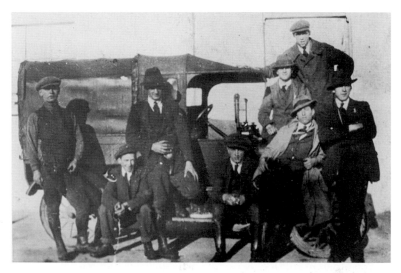

Members of the Dublin ASU at a training camp in Artane during the Truce. Although hostilities had ceased, it was believed by the IRA and indeed the British military that the Truce was only a temporary measure and that the conflict could be renewed at any time. In order to keep the men alert, training camps were set up all over the country in which the IRA continued to drill and prepare for battle. The men shown are M. Stack, S. Conroy, W. Walsh, M. O'Reilly, T. Flood, J. McHenry, R. Murphy and E. Flood.
Courtesy of Kilmainham Gaol Archives, 19PC-1B51-04.

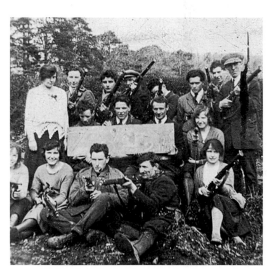

Members of Cumann na mBan and the IRA pose for a photograph during the Truce.

Courtesy of Kilmainham Gaol Archives, 17PC-1A41-30i.

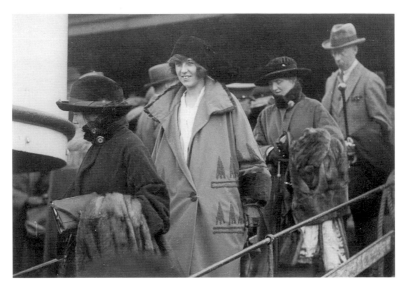

Members of the Irish delegation who were travelling to London to negotiate a treaty with Britain leaving the *Curraghmore* upon arrival at Holyhead, Wales, on 8 October 1921. *Left to right:* Alice Lyons, Kathleen McKenna, Ellie Lyons, Robert Barton.

Courtesy of Mercier Archives.

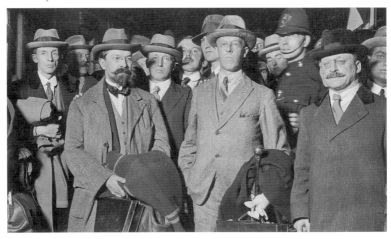

Arrival of the first contingent of the Irish delegates at Euston Station, London, on 9 October. *Left to right:* Erskine Childers, George Gavan Duffy, Art O'Brien, Joe McGrath (only partially visible), Robert Barton, Arthur Griffith.

Courtesy of Mercier Archives.

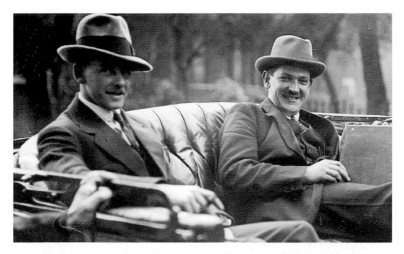

Emmet Dalton and Michael Collins during the Treaty negotiations, 11 October.
Courtesy of Mercier Archives.

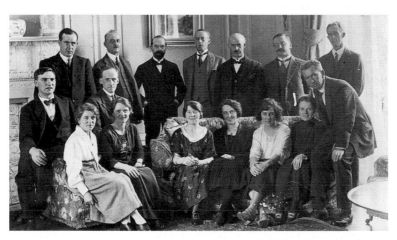

Hans Place, London, the headquarters of the delegation. This shows members of the delegation on their return from the first day's talks, 11 October. *Front row, left to right:* Miss Lily Brennan (Childers' typist), Miss Ellie Lyons, Mrs Eamonn Duggan, Mrs Fionan Lynch, Miss Kathleen McKenna, Miss Alice Lyons. *Second row, left to right:* Joe McGrath, Captain David Robinson, Fionán Lynch (secretary to delegation). *Third row, left to right:* Mick Knightly (official reporter), John Chartres (secretary to delegation), George Gavan Duffy, Robert Barton, Eamonn Duggan, Arthur Griffith, Erskine Childers.
Courtesy of Mercier Archives.

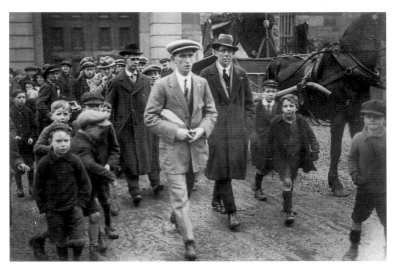

Under the terms of the Treaty, which was signed on 6 December, all members of the IRA in British custody were to be released. The releases began on 8 December. Here, a prisoner is being freed from Mountjoy Jail.

Courtesy of Kilmainham Gaol Archives, 19PC-1A58-07.

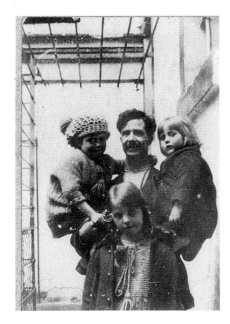

Frank Carberry and his children. This photograph was taken on the top floor of the East Wing, Kilmainham Gaol, just before Carberry's release under the terms of the Treaty.

Courtesy of Kilmainham Gaol Archives, 19PC-1A54-09a.

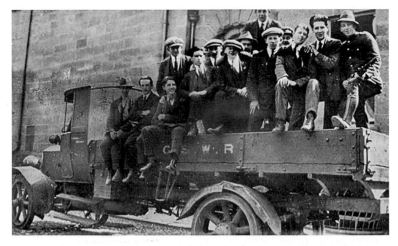

A group of men standing on a truck belonging to Great Southern and Western Railway after their release from prison in December 1921.

Courtesy of Kilmainham Gaol Archives, 2011.0464.

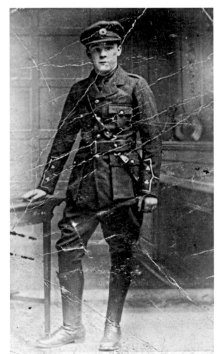

Patrick Brogan, seen here in his Na Fianna Éireann officer's uniform, after his release from Kilmainham Gaol in 1921.

Courtesy of Kilmainham Gaol, 19PD-1A14-06.

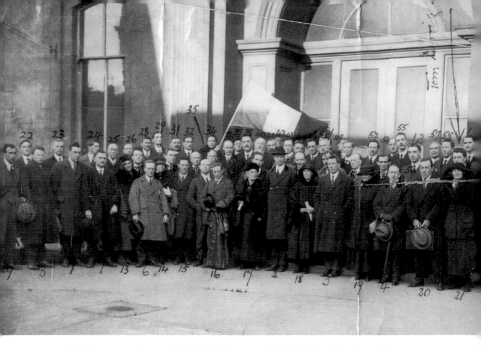

Anti-Treaty members of the Dáil, January 1922. When the signed Treaty was brought back to Dublin for ratification, almost immediately there was division in the Dáil. After numerous debates between those TDs for and against the Treaty, a vote was taken in the Dáil on 7 January. The Treaty was approved by sixty-four votes to fifty-seven. As a result of the vote the anti-Treaty members of the Dáil left the proceedings. This photograph was just one of a number of photographs gathered by Michael Collins' intelligence division, later the CID, of those who took the anti-Treaty side in the Civil War that was about to follow. As can be seen, all members are numbered and were identified. 1) P. Ruttledge, 2) E. de Valera, 3) A. Stack, 4) S. T. O'Kelly, 5) J. McDonagh, 6) L. Mellows, 7) J. J. O'Kelly, 8) T. Maguire, 9) S. Devins, 10) S. Robinson, 11) J. Doherty, 12) F. Carty, 13) Countess Markievicz, 14) Mrs O'Callaghan, 15) S. Doyle, 16) Cathal Brugha, 17) Mrs Pearse, 18) Mrs Clarke, 19) Mary MacSwiney, 20) Harry Boland, 21) Ada English, 22) Dr Ferran, 23) D. J. Crowley, 24) S. Moylan, 25) Prof. Stockley, 26) M. P. Colivet, 27) ? Aylward, 28) D. Corkery, 29) F. Fahy, 30) S. Fitzgerald, 31) Phil Shanahan, 32) P. Cahill, 33) Count P. J. O'Byrne, 34) Frank Casey, 35) R. C. Barton, 36) Brian O'Higgins, 37) Tom O'Donoghue, 38) John O'Mahony, 39) Seán MacEntee, 40) G. N. Count Plunkett, 41) D. Buckley, 42) Dr Jim Ryan, 43) D. O'Callaghan, 44) Éamon Dee, 45) Art O'Connor, 46) Con Collins, 47) Seán Etchingham, 48) Dr Brian Cusack, 49) Seán MacSwiney, 50) Erskine Childers, 51) C. Murphy, 52) James Lennon, 53) Seán Nolan, 54) Éamon Roche, 55) D. Kent, 56) F. Carty (numbered twice in the photo, also 12), 57) Unidentified, 58) P. J. McCarthy and Tom Derrig.

Courtesy of Military Archives Dublin, IE-MA-CP-A-0863.

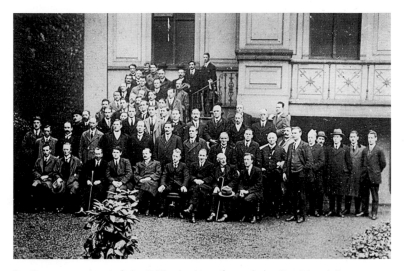

Pro-Treaty members of the Dáil who later formed the Provisional Government gather for a photograph in the grounds of the Mansion House.

Courtesy of Kilmainham Gaol Archives, 20PO-1A35-16.

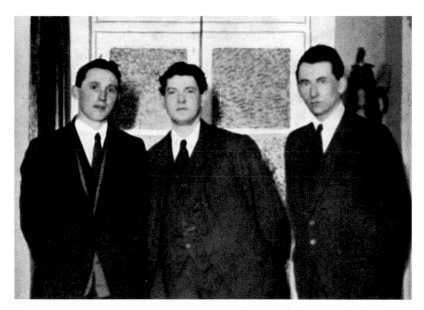

Left to right: Tom Cullen, Michael Collins and Frank Thornton. This photograph was taken in the Gresham Hotel on the night that the Treaty was approved.

Courtesy of Mercier Archives.

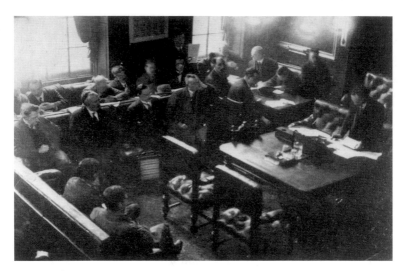

Ratification of the Treaty, Oak Room, Mansion House, 14 January 1922. Michael Collins is sitting opposite the Speaker, W. T. Cosgrave, on the left of the front bench; Arthur Griffith sits second from right on the part of the front bench facing the camera.

Courtesy of Kilmainham Gaol Archives, 20PC-1A45-24.

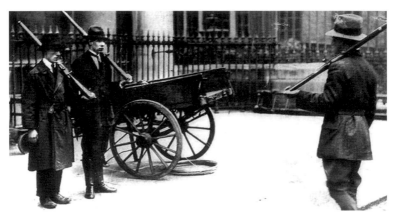

An IRA guard at Dublin Castle. Captain Tom Maguire, 5th Battalion, is second from left. Maguire was captain in the 3rd Engineers, 5th Battalion, during the War of Independence. He took the anti-Treaty side during the Civil War. He was killed with three other anti-Treaty IRA men on 18 November 1922 when the mine they were transporting prematurely exploded. He was twenty-two years old.

Courtesy of Mick Doyle and Richard O'Driscoll.

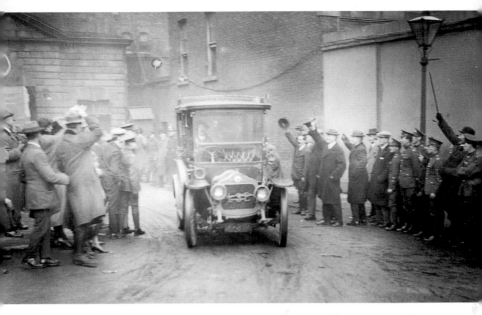

The handover of Dublin Castle to the Provisional Government, 16 January 1922.
Michael Collins' car arrives at Dublin Castle.

Courtesy of Mercier Archives.

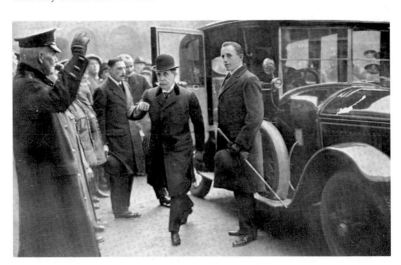

Viscount FitzAlan arrives at Dublin Castle. FitzAlan was the last lord lieutenant of
Ireland, having replaced Lord French in April 1921.

Courtesy of Kilmainham Gaol Archives, 19PC-1A26-17.

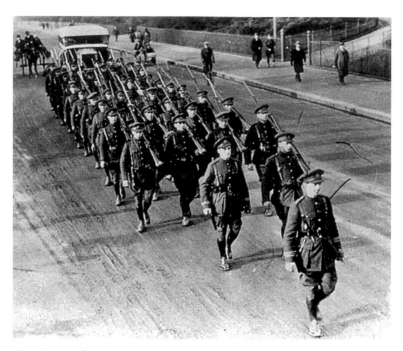

The takeover of Beggars Bush Barracks, 31 January 1922. Members of the 'Dublin Guard', consisting of no more than fifty men, led by Brigadier-General Paddy O'Daly, march through the capital on their way to formally take over Beggars Bush from the British.

Courtesy of the Labour Museum, Dublin.

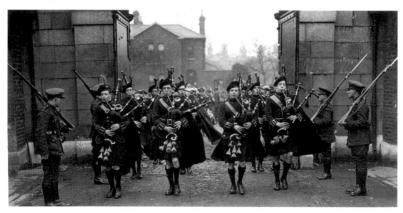

The Fintan Lalor Pipe Band enters Beggars Bush Barracks.

Courtesy of Kilmainham Gaol Archives, 19PC-1B51-04.

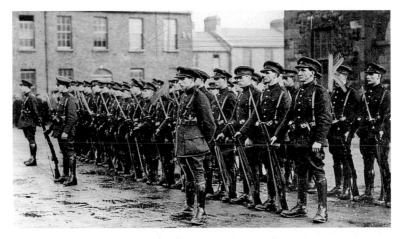

The first soldiers of the National Army. Members of the Dublin Guard line up in formation at Beggars Bush Barracks. Prior to the end of the War of Independence the Squad and the Active Service Unit were amalgamated and placed under the leadership of Paddy O'Daly. These men were the nucleus of what would become the new National Army. Standing front and centre is Pádraig O'Connor, a veteran of the War of Independence.

Courtesy of the Labour Museum, Dublin.

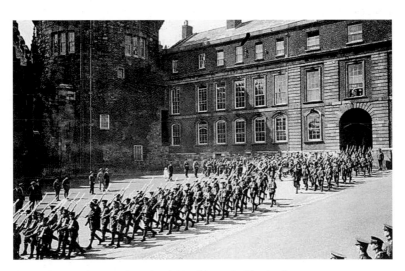

The 20th Lancashire Fusiliers (20th Foot) leave Dublin Castle.

Courtesy of James Langton.

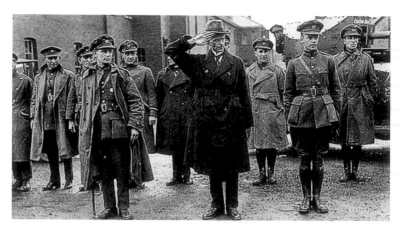

Salute to the soldiers at Portobello Barracks, Dublin. *Front, left to right:* Commandant Tom Ennis, General Eoin O'Duffy and Colonel Emmet Dalton. Fionán Lynch is behind Tom Ennis, second from left.
Courtesy of the Labour Museum, Dublin.

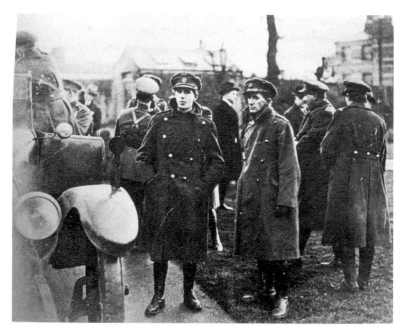

General Seán MacMahon and General Richard Mulcahy at Portobello Barracks.
Courtesy of the Labour Museum, Dublin.

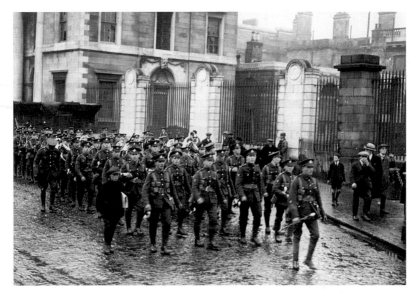

British soldiers march past the ruined Custom House on their way to the North Wall to board a ship back to England.

Courtesy of Kilmainham Gaol, 19PC-1B51-04.

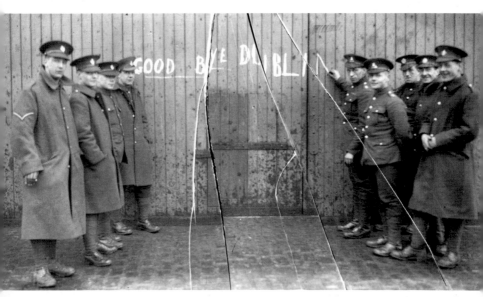

Happy to be leaving. A group of soldiers bid farewell to Dublin.

Courtesy of the National Library of Ireland.

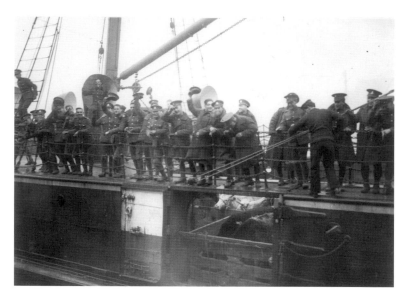

British soldiers wave goodbye to Ireland.
Courtesy of Mercier Archives.

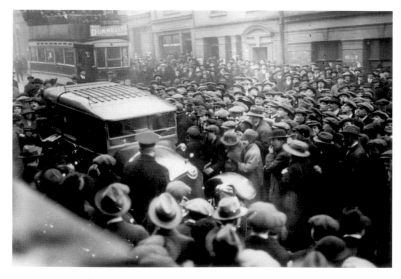

City Hall, 2 February 1922. Delegates arrive at City Hall for the conference between Michael Collins and Sir James Craig, Prime Minister of Northern Ireland.
Courtesy of Mercier Archives.

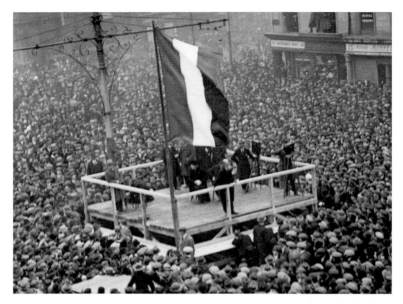

Count Plunkett addresses thousands of people at an anti-Treaty demonstration in March 1922 at the top of O'Connell Street.
Courtesy of Mercier Archives.

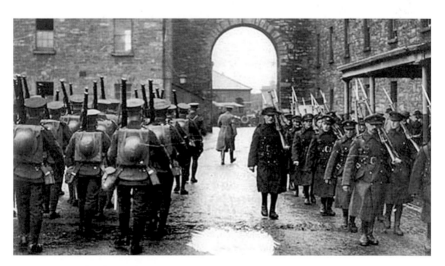

Handover of Richmond Barracks, Inchicore. As members of the National Army enter the barracks the British troops evacuate.
Courtesy of the Labour Museum Dublin.

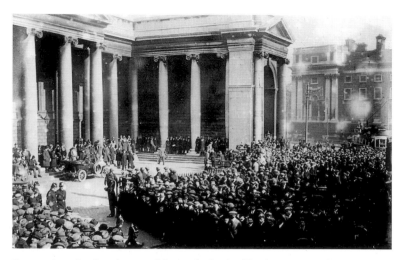

Preparations for the takeover of the Bank of Ireland by the Provisional Government, College Green, March 1922. The Bank of Ireland was the official bank of the State, and as massive deposits of money were held there it had to be secured.

Courtesy of Mercier Archives.

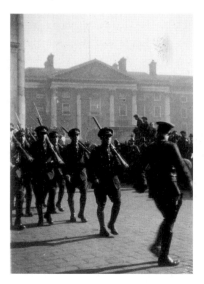
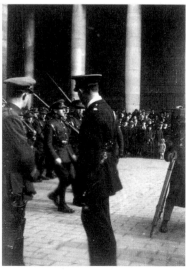

Soldiers practise marching in readiness for the ceremony, while others discuss the logistics of it. In the left picture, Trinity College can be seen in the background.

Courtesy of Military Archives Dublin, IE-MA-PC-59 Photo of Soldiers at Bank of Ireland No. 5; Photo of Soldiers at Bank of Ireland No. 3.

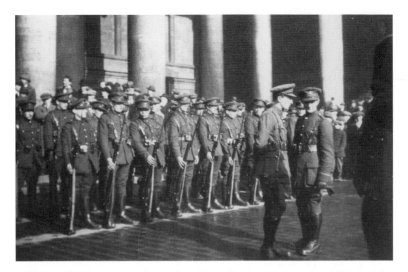

Soldiers talking amongst themselves. Vinny Byrne, commanding officer of the bank guard, is looking at the camera.

Courtesy of Military Archives Dublin, IE-MA-PC-59, Photo of Soldiers at Bank of Ireland No. 1.

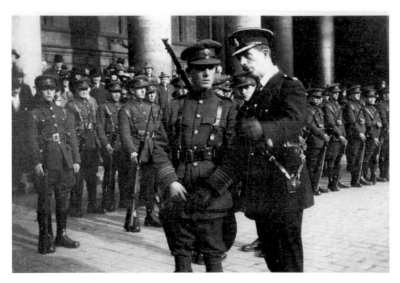

A soldier and a Bank of Ireland official discuss the logistics of the ceremony.

Courtesy of Military Archives Dublin, IE-MA-PC-59 Photo of Soldiers at Bank of Ireland No. 2.

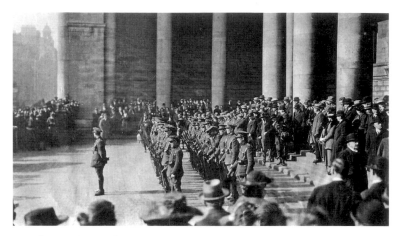

A professional army. The Dublin Guard on parade outside the Bank of Ireland.
Courtesy of Christina Broe.

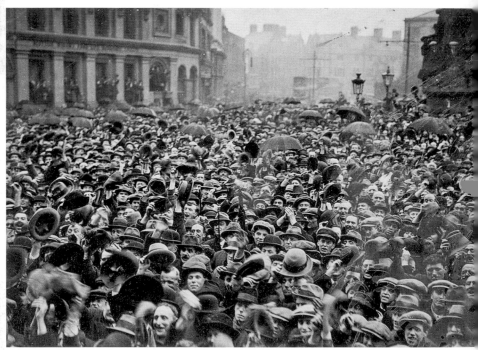

The crowds cheer as Arthur Griffith speaks at a pro-Treaty rally in March 1922, College Green.
Courtesy of Kilmainham Gaol Archives, 19PC-1B51-04.

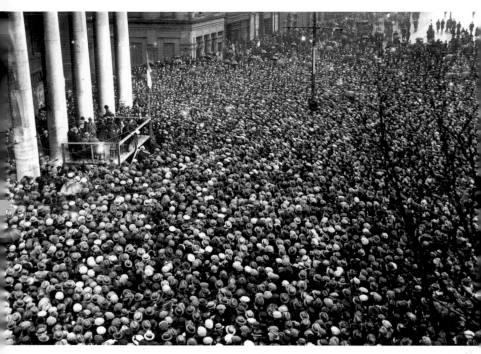

Crowds gathered at College Green to hear Michael Collins speak at the pro-Treaty rally.

Courtesy of Mercier Archives.

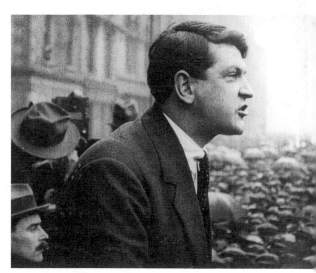

Michael Collins addressing the rally.

Courtesy of Mercier Archives.

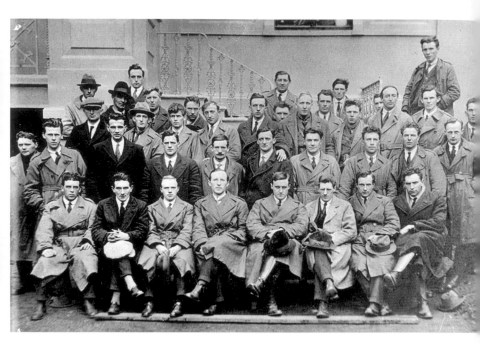

The second Irish Republican Army Convention, Mansion House, 9 April 1922. During the War of Independence the IRA was brought under the control of Dáil Éireann as the army of the Irish Republic. When the Treaty was ratified by the Dáil, the IRA decided to hold an Army Convention on 26 March to decide whether or not to revert to its independent position, as many of its members opposed the Treaty. The convention was attended only by the anti-Treaty IRA and they reaffirmed their allegiance to the Republic and elected an Executive. A second convention was held on 9 April at which a new Republican Constitution was ratified and they pledged to uphold the Republic and to serve an established Republican government that was loyal to that Republic and its people.

First row, left to right: Seán Lehane, Tom Daly, Florrie O'Donoghue, Liam Lynch, Liam Deasy, Seán Moylan, John Joe Rice, Humphrey Murphy. *Second row, left to right:* Denis Daly, Jimmy O'Mahony, George Power, Michael Murphy, Eugene O'Neill, Seán MacSwiney, Dr Pat O'Sullivan, Jim Murphy, Moss Donegan, Gerry Hannifin. *Third row, left to right:* Jeremiah Riordan, Michael Crowley, Dan Shinnick, Con Leddy, Con O'Leary, Tom Hales, Jack O'Neill, Seán McCarthy, Dick Barrett, Andy Cooney. *Fourth row, left to right:* Tom Ward, John Lordan, Gibbs Ross, Tadhg Brosnan, Dan Mulvihill, Denis McNeilus. *At back, left to right:* Con Casey, Pax Whelan, Tom McEllistrim, Michael Harrington.

Courtesy of Kilmainham Gaol Archives, 20PC1A26-22(1).

The interior of the Freemason's Hall, Molesworth Street. The Freemason's Hall was taken over by the anti-Treaty forces soon after they occupied the Four Courts in April 1922. When they eventually evacuated the building, it was found to be in perfect condition – no damage had been inflicted on the premises. Of interest in this photograph are the masonic symbols.

Courtesy of Kilmainham Gaol Archives, 2011.0226.

Another view of the interior of the Freemason's Hall.

Courtesy of Kilmainham Gaol Archives, 2011.0226.

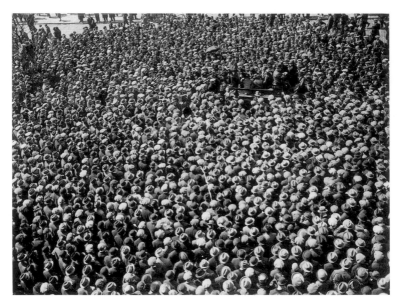

Anti-militarism meeting, 24 April. In response to the growing tension between the pro- and anti-Treaty forces, the Irish Labour Party condemned the threat of force by both sides and called for a National Strike in the twenty-six counties. They were successful and there was a complete stoppage of all public services including transport and communication. A mass meeting was then held in O'Connell Street, which was attended by thousands of people.

Courtesy of Kilmainham Gaol Archives, 20PO-1A35-15.

The Labour leader, Thomas Johnson, addresses the crowds.

Courtesy of Kilmainham Gaol Archives, 19PC-1B51-04.

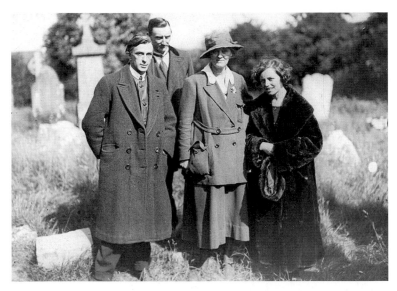

Anti-Treaty commemoration of Wolfe Tone at Bodenstown in April 1922. *Left to right:* Rory O'Connor, Oscar Traynor, Countess Markievicz and Muriel MacSwiney.
Courtesy of Kilmainham Gaol Archives, 20PO-1A35-21b.

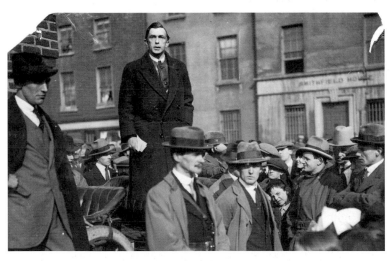

In an anti-Treaty demonstration, Rory O'Connor addresses crowds gathered in Smithfield *c.* April 1922. Peadar Breslin, veteran of the Easter Rising and the War of Independence is below him, looking towards the camera.
Courtesy of Peter McMahon and the Breslin family.

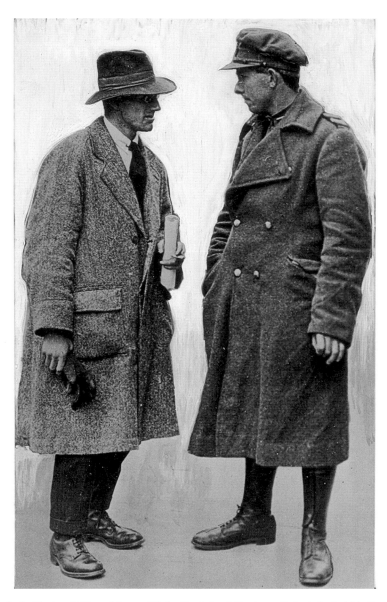

Seán Moylan (*left*) and General Seán MacEoin at the Army Unity talks held in the Mansion House, 1 May. The talks were an attempt to avoid civil war breaking out. A committee of ten members, five from both sides, was set up, but despite their best efforts it was all to no avail.

Courtesy of Kilmainham Gaol Archives, 19PC-1B51-04.

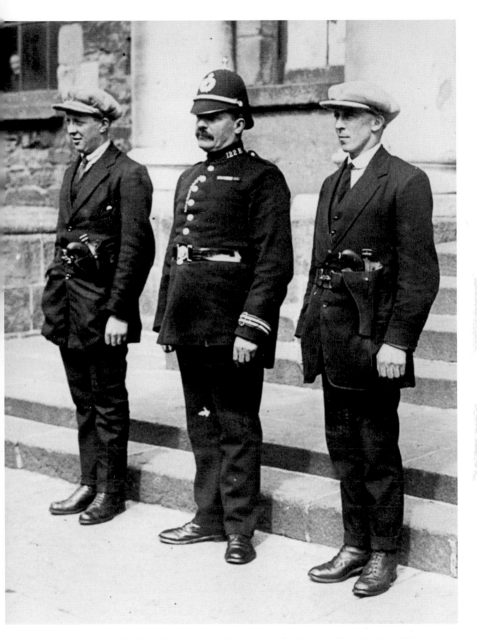

The opening of the British Reparation Committee for Ireland, May 1922. A DMP constable is flanked by two members of the Irish Republican Police.

Courtesy of Mercier Archives.

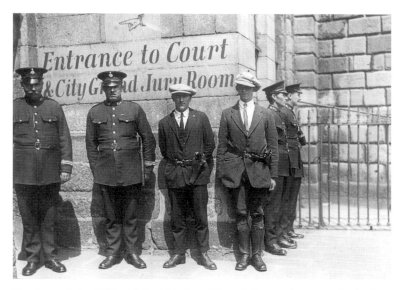

Members of the DMP and the Irish Republican Police on duty outside the Four Courts during the general election, June 1922. The anti-Treaty IRA had taken over the Four Courts in April.

Courtesy of Mercier Archives.

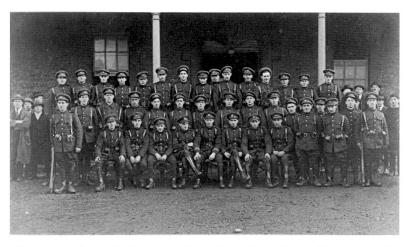

Members of the Dublin Guard who fought in the Easter Rising. This photograph was taken in Beggars Bush barracks, 1922.

Courtesy of Kilmainham Gaol, 20PO-1A35-19.

1922-23:
CIVIL WAR

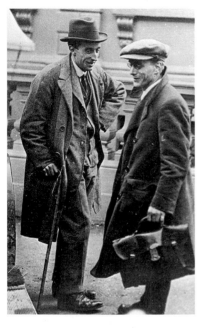

Liam Mellows (*right*) talking to an unidentified man before the outbreak of the Civil War. Mellows was a member of the IRB and actively involved from an early stage in the organisation of Na Fianna Éireann. He opposed the Treaty and was a member of the anti-Treaty IRA Executive which occupied the Four Courts in April 1922. Arrested after the surrender of the Four Courts garrison on 30 June, he was taken to Mountjoy Jail. He was subsequently executed on 8 December in Mountjoy with Dick Barrett, Joe McKelvey and Rory O'Connor, in reprisal for the shooting of Seán Hales on 7 December 1922.

Courtesy of Kilmainham Gaol Archives, 19PC-1B51-04.

When the British evacuated their forces they handed over their barracks to the local IRA brigade, regardless of whether they were pro- or anti-Treaty. Dublin was the exception and only pro-Treaty companies were allowed to take over the numerous city barracks. Here a pro-Treaty/National Army motorcyclist poses in Richmond (later Keogh) Barracks, Inchicore.

Courtesy of Kilmainham Gaol Archives, 20PO-1A34-04.

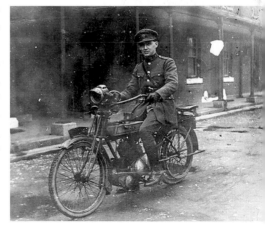

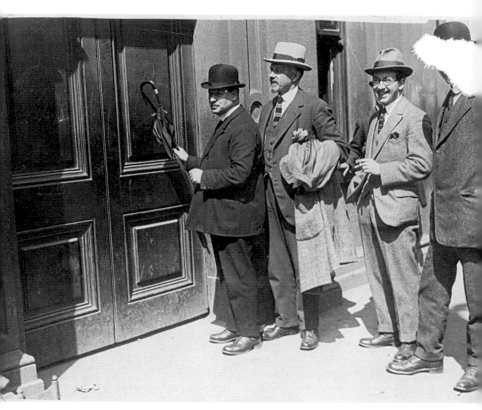

Lord Mayor of Dublin Laurence O'Neill and officials demanding admittance to the Ballast Office on Westmoreland Street/Aston Quay, which had been taken over by the anti-Treaty forces after they occupied the Four Courts. The anti-Treaty soldiers eventually evacuated the building on 26 May, handing it over to the lord mayor. When the fighting at the Four Courts ended and the battle shifted to O'Connell Street, it was taken over by the pro-Treaty forces as a key location for the attack on O'Connell Street.

Courtesy of Kilmainham Gaol Archives, 20PO-1A34-11.

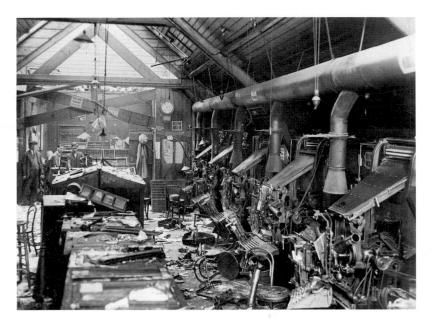

The offices of *The Freeman's Journal* in Dublin after they were destroyed in 1922 by members of the anti-Treaty forces as a result of the newspaper's pro-Treaty stance. This image shows the linotype and composing room.

Courtesy of Kilmainham Gaol Archives, 20PO-1A35-20.

William Doyle (*standing*) with an un-identified man kneeling next to him aiming his gun in the Four Courts. Doyle is in civilian clothes, wearing a Sam Browne belt and holding a revolver. Doyle was a veteran of the War of Independence and was arrested following the burning of the Custom House in May 1921 and subsequently imprisoned in Arbour Hill and Kilmainham Gaol. He took the pro-Treaty side initially, but then left and joined the ranks of the anti-Treaty IRA.

Courtesy of Kilmainham Gaol Archives, OBJ0016.

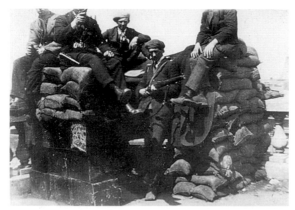

Unnamed men on the roof of the Four Courts before the outbreak of the Civil War.

Courtesy of Kilmainham Gaol Archives, 20PO-3N25-02c.

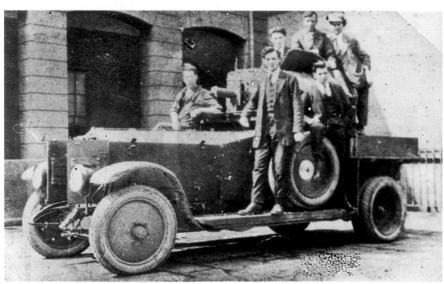

Members of the Four Courts garrison on board the captured armoured car 'The Mutineer' before the outbreak of the war. This car was vital to the garrison during the battle of the Four Courts as the pro-Treaty forces were well equipped with weapons and armoured cars. The crew of 'The Mutineer' were constantly under fire and kept up stiff resistance until it was finally put out of action on the morning of 30 June. With this line of protection now gone, the anti-Treaty forces inside the Courts came under increasingly heavy fire from the pro-Treaty forces. Later that day, realising that their position was untenable, the anti-Treaty forces had no other option but to surrender.

Courtesy of Kilmainham Gaol Archives, 20PO-1A34-06.

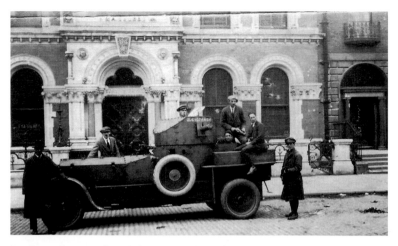

Pro-Treaty forces on board the armoured car 'Slieve na mBan'.
Courtesy of Christina Broe.

Peadar O'Donnell, a veteran of the War of Independence, rejected the Treaty and was a member of the anti-Treaty IRA Executive. Arrested after the fall of the Four Courts he was imprisoned in Mountjoy Jail. His book *The Gates Flew Open* is an account of his experiences in the Civil War.
Courtesy of Mercier Archives.

Military advisor to the government in Northern Ireland, Field Marshal Sir Henry Wilson had long been an enemy of the IRA. His assassination on 22 June by members of the London IRA led to the British exerting pressure on the Provisional Government to act against the Four Courts garrison. Collins refused, so the British put in place their own plans to attack, but realising that such an action might reunite the IRA, they waited. Finally, with the kidnapping of General J. J. 'Ginger' O'Connell by the anti-Treaty forces on 26 June, Collins finally realised he had to act, and preparations were made to launch an assault on the Four Courts.
Courtesy of Mercier Archives.

Commandant Tom Ennis (*right with cane*) and two unidentified men. Fiercely loyal to Collins, he accepted the Treaty, and most of his men in the 2nd Battalion followed him, the only battalion to do so in the Dublin Brigade. When it was decided to attack the Four Courts it was down to Ennis as commandant of the 1st Eastern Division to order the surrender of the garrison. When the anti-Treatyites refused, he ordered that the attack go ahead, and it commenced at 4.10 a.m. on 28 June.

Courtesy of Kilmainham Gaol Archives, 20PO-1A34-03.

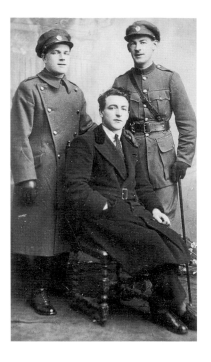

Pádraig O'Connor, a member of the 4th Battalion, Dublin Brigade, was also a member of the Dublin ASU during the War of Independence. He later became commandant of No. 4 Section, ASU, and took part in many operations against crown forces, including the burning of the Custom House in May 1921. He was ordered to attack the Courts from the western side where the Records Office stood. His group were the first to gain entry into the complex and had just entered the Records Office when a massive explosion occurred. Amazingly he was not hurt in the explosion. He later went on to become director of operations in Portobello Barracks.

Courtesy of Diarmuid O'Connor.

Colonel Joe Leonard was to head a frontal assault on the Four Courts from the eastern side. He was wounded just as his men were about to enter the breach made in the complex by the 18-pounder guns being used by the pro-Treaty forces.

Courtesy of James Langton.

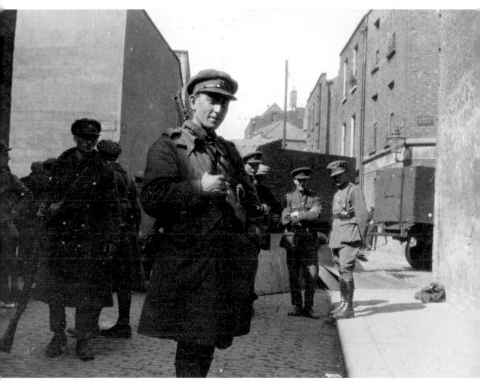

Pro-Treaty troops gather at Lincoln Lane waiting to attack the Four Courts. Hammond Lane is to the right.

Courtesy of the National Museum of Ireland.

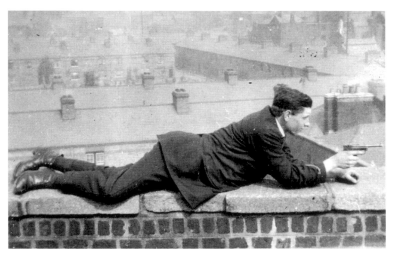

Paddy Rigney on the roof of the Four Courts, 1922. Rigney was a member of the 4th Battalion, Dublin Brigade. A veteran of the War of Independence, he took the anti-Treaty side during the Civil War and fought in the Four Courts. After the surrender the garrison was taken to Jameson's Distillery to await transport to prison. It was while there that his good friend Pádraig O'Connor, pro-Treaty, helped him and four others to escape. Despite being political enemies the two men were to remain great friends for the rest of their lives.
Courtesy of Military Archives Dublin, IE-MA-PC-765.

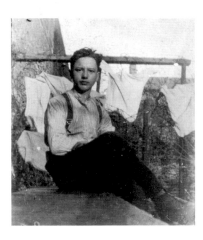

A member of Na Fianna, Thomas Wall had already seen action in the War of Independence and had been imprisoned in Kilmainham Gaol for his activities. Like most members of Na Fianna he took the anti-Treaty side in the Civil War, and he was a member of the orderlies section in the Four Courts stationed in the Records Office. This section was made up mainly of young men from Na Fianna and they came under the heaviest attack throughout the battle. Wall and another Volunteer, Seán Cusack, were killed when the pro-Treaty forces gained entry. He was eighteen years old.
Courtesy of Kilmainham Gaol Archives, 19PO-1A32-16a.

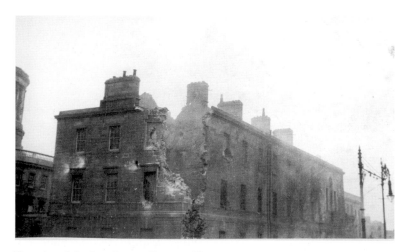

The ruins of the Four Courts, Chancery Place.
Courtesy of Military Archives Dublin, IE-MA-PC-59, A.E. Lawlor Collection.

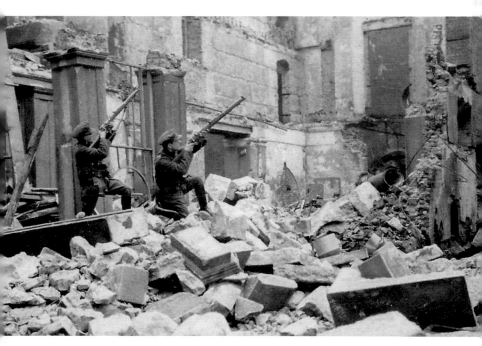

Pro-Treaty troops pose amongst the ruins of the Four Courts.
Courtesy of Christina Broe.

The breach leading into the Records Office of the Four Courts. This area suffered the heaviest attack from the pro-Treaty forces who had an 18-pounder gun directly opposite the building in Hammond Lane, less than thirty feet away.

Courtesy of Diarmuid O'Connor.

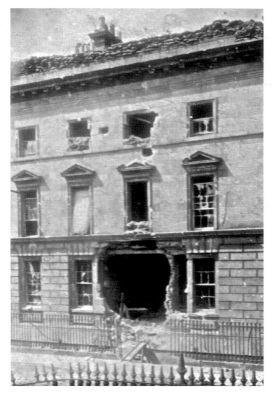

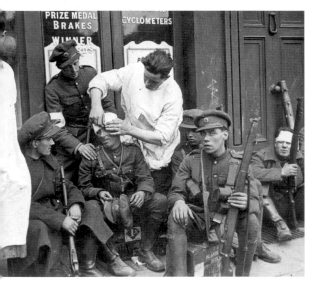

A wounded soldier receives treatment from a doctor on the streets amid the fighting.

Courtesy of Mercier Archives.

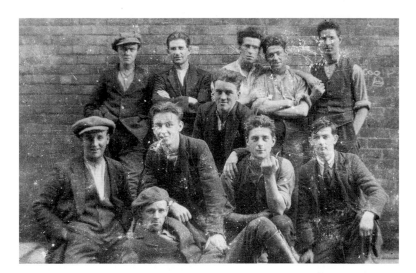

Anti-Treaty IRA prisoners in Mountjoy Jail during the Civil War. *Standing, left to right:* Dirr McNeill, Charlie Weston, Diggers Nolan, Leo Fox, Tom O'Reilly. *Kneeling, left to right:* Vincent Lawlor, Tom Daly, Unidentified, Liam Mulcahy, Christy Clarke. *Lying down:* Eddie Horn.
Courtesy of Kilmainham Gaol Archives, 20PC-3N25-05.

Vincent Lawlor, anti-Treaty IRA. Lawlor fought in the Four Courts at the outbreak of the Civil War. He, along with the rest of the Four Courts garrison, was taken to Mountjoy Jail after the surrender on 30 June 1922. This photograph was part of a number of photographs taken by the Four Courts garrison while in Mountjoy Jail.
Courtesy of Kilmainham Gaol Archives, 20-PC-3N25-05.

Volunteer Seán Mulcahy in Mountjoy Jail, 1922.
Courtesy of Kilmainham Gaol Archives, 20PC-3N25-05.

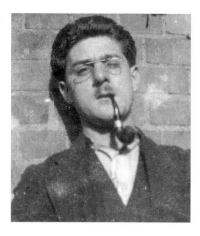

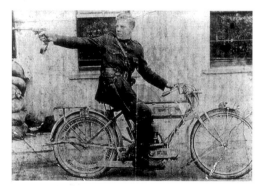

Jimmy Conroy on his motorbike during the Civil War. Conroy had been a member of 'The Squad' and took the pro-Treaty side during the Civil War.
Courtesy of James Langton.

Seán Prendergast, OC of C Company, 1st Battalion, Dublin Brigade, opposed the Treaty and was OC of the anti-Treaty garrison in Hughes Hotel. He was arrested and imprisoned in Kilmainham Gaol. Seán died in 1953 at the age of fifty-nine.
Courtesy of Kilmainham Gaol Archives, 21MT-1C11-22.

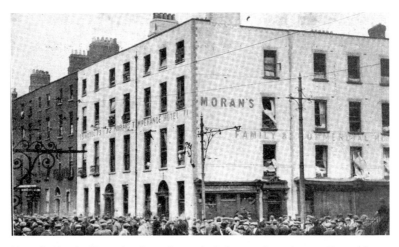

Moran's Hotel. After the Four Courts had been taken the pro-Treaty forces concentrated their assault on the anti-Treaty positions in O'Connell Street and the surrounding areas. Moran's Hotel and Hughes Hotel on the corner of Talbot Street were the next outposts to come under attack and were taken on Saturday 31 June.
Courtesy of Kilmainham Gaol Archives, 20PD-1A14-10.

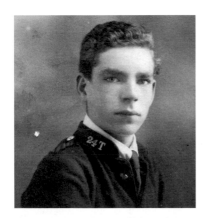 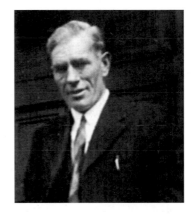

Brothers Bill (*left*) and Jack Cregan were members of K Company, 3rd Battalion, Dublin Brigade. Jack took part in the burning of the Custom House in 1921. K Company was responsible for taking over Tara Street Fire Brigade Station to prevent the Fire Brigade from getting to the building. It was successful in holding the station and fled before the Auxiliaries arrived. Bill saw action in the Four Courts during the Civil War and was arrested near Portobello Barracks in July 1922.
Both photos courtesy of Kate Walton, Sheila Maguire and the Cregan family.

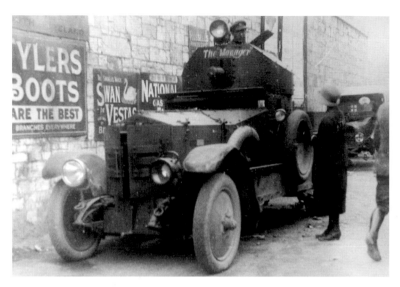

The armoured car 'The Manager'. All the armoured cars were named and this particular car was named after Tom Ennis, OC of the 2nd Battalion, Dublin Brigade, who, during the War of Independence, was given the nickname 'The Manager'. During the Civil War he was commandant of the 1st Eastern Division, National Army.

Courtesy of Kilmainham Gaol Archives, 19PC-1D41-16a.

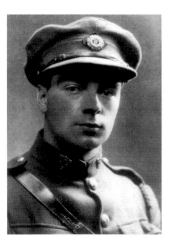

George Hampton, seen here wearing his National Army uniform, was a veteran of the War of Independence. He took the pro-Treaty side during the Civil War. During the early days of the fighting in Dublin he was wounded when visiting his family home at Hampton's Grocers, the business owned by his family. It was located at St Mary's Abbey, quite close to the Four Courts, and as George was getting off his motor bike, wearing his army uniform, he was shot through the chest by a sniper in the Four Courts. Two men, a milk float driver and an elderly man, were shot dead while trying to go to his aid. Hampton survived his injuries and spent three months convalescing in Jervis Street Hospital.

Courtesy of Kilmainham Gaol Archives, 2010.0105.

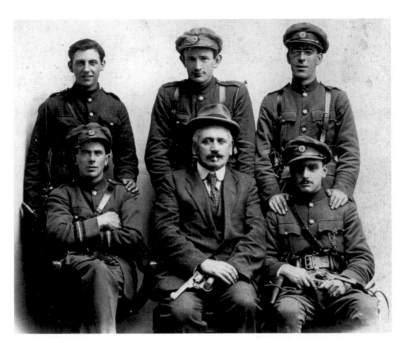

National Army soldiers, 1922: Front row, left, is Jim Slattery. Back row, middle, is Tom Keogh. Both were members of 'The Squad' and both took part in the burning of the Custom House in May 1921. Slattery was wounded, resulting in him losing his left hand, while Keogh was arrested and imprisoned in Kilmainham Gaol. Keogh was killed in Carrigaphooca, County Cork, on 16 September 1922 while trying to clear a mine that had been placed on a roadway by anti-Treaty forces. He was twenty-three years old.

Courtesy of Kilmainham Gaol Archives, 2010.0020.

Paddy Kelly. A member of G Company, 1st Battalion, Kelly fought in North King Street during the Rising and was an active member of the IRA during the War of Independence. He took the anti-Treaty side during the Civil War, fighting in Capel Street, and was arrested there on Saturday 1 July. The arresting officer was Jim Slattery.

Courtesy of Paddy Kelly.

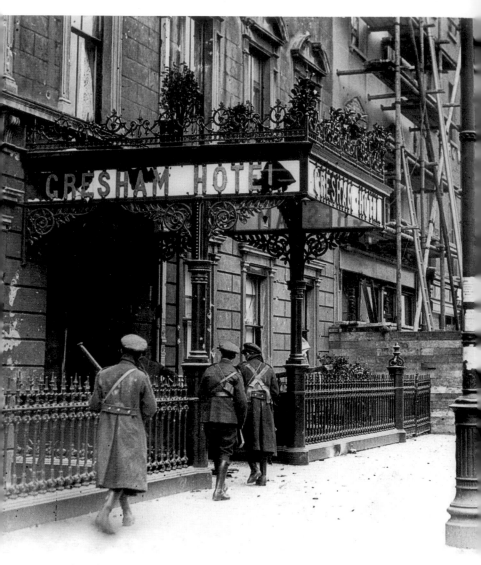

When the Civil War broke out, the anti-Treaty IRA took over a row of buildings on the east side of O'Connell Street stretching from Gregg's Lane (now Cathal Brugha Street) to Tyrone Street (now Cathedral Street) which was nicknamed 'The Block'. The buildings were all linked up as the anti-Treaty IRA had burrowed through them and it was here that Oscar Traynor set up his headquarters. Here pro-Treaty forces advance on one of the buildings in 'The Block', the Gresham Hotel.

Courtesy of Mercier Archives.

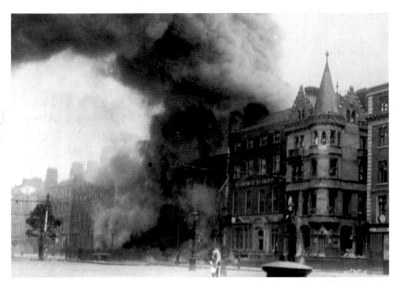

'The Block' on fire. After a sustained attack on 'The Block' the anti-Treaty forces were forced to surrender. Almost the entire block of buildings including the Granville, Gresham and Hammam Hotels were destroyed.
Courtesy of Diarmuid O'Connor.

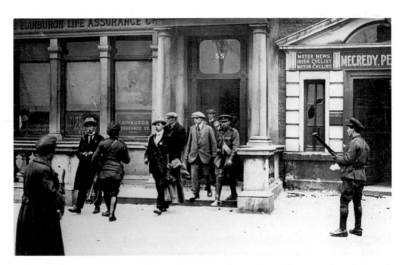

A group of anti-Treaty prisoners walking out of 55 O'Connell Street, The Edinburgh Life Assurance Company, surrounded by pro-Treaty troops.
Courtesy of Kilmainham Gaol Archives/Topical Press, 20PO-1A34-25.

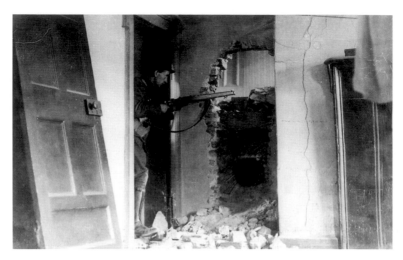

A soldier makes a search of an anti-Treaty outpost. This photograph was most likely taken in 'The Block' or the buildings between Findlater's at Findlater Place and Bridgeman's at Parnell Street. In both strongholds the anti-Treaty forces tunnelled their way through the buildings. For the pro-Treaty forces, searching these buildings for survivors was a hazardous task, as there could be any number of Republicans hiding, waiting to attack them.

Courtesy of the National Library of Ireland.

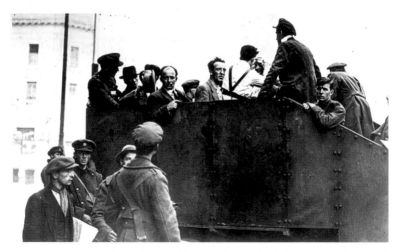

Members of the anti-Treaty forces under guard after the fighting in Dublin ended, 5 July 1922. This photograph was taken at the top of O'Connell Street.

Courtesy of Kilmainham Gaol Archives/Topical Press, 20PC-1A45-10.

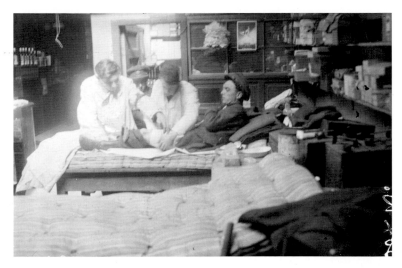

A soldier receives treatment for his wounds.
Courtesy of the National Library of Ireland.

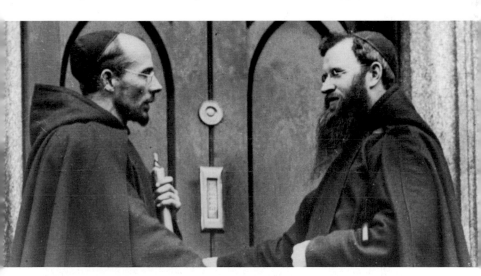

Fr Albert (*left*) and Fr Dominic, Capuchin Friars, Church Street. Their support to the Volunteers from 1916 right through to the Civil War was steadfast. They were often to be found amid the fighting. It was they who gave spiritual support to the condemned leaders in Kilmainham Gaol, and Fr Albert was himself in the Four Courts and later 'The Block' giving solace to the anti-Treaty forces.
Courtesy of Mercier Archives.

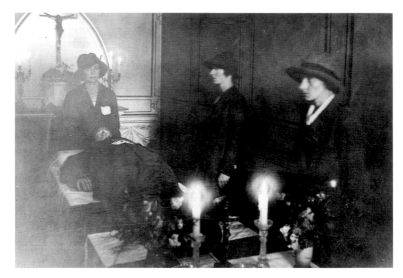

Cathal Brugha lying-in-state with a Cumann na mBan guard of honour, at the Mater Hospital, 10 July 1922. Brugha was mortally wounded by pro-Treaty soldiers on 5 July after refusing to surrender.

Courtesy of Kilmainham Gaol Archives, 20PO-1A35-17.

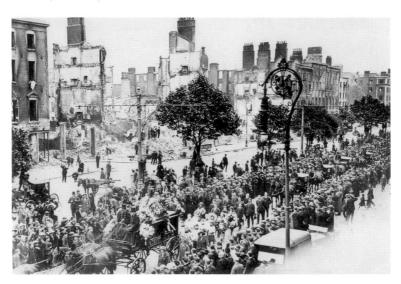

Cathal Brugha's funeral passing through O'Connell Street, 10 July 1922. In the background are the ruins of 'The Block', where Brugha was shot.

Courtesy of Kilmainham Gaol Archives, 20PO-1A35-04.

The ruins of the Grosvenor Hotel, Westland Row, after the fighting.

Courtesy of Mercier Archives.

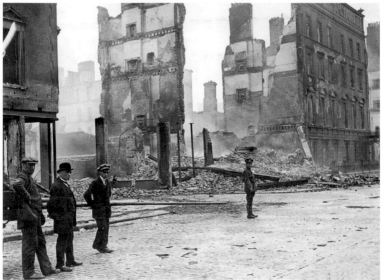

Part of O'Connell Street after the fighting ended.

Courtesy of Mercier Archives.

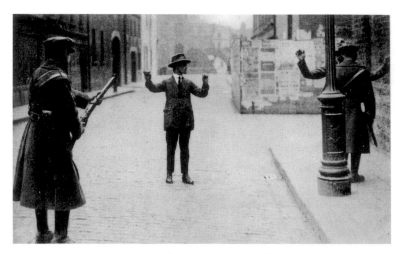

National Army soldiers stop and search civilians on Liffey Street, sometime after the fighting in Dublin had ended. The Ha'penny Bridge can be seen in the background.
Courtesy of Gary Deering.

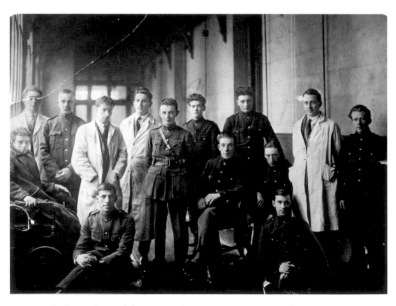

Unidentified members of the National Army and medical staff in Jervis Street Hospital.
Courtesy of Kilmainham Gaol Archives, 17PO-1K53-15.

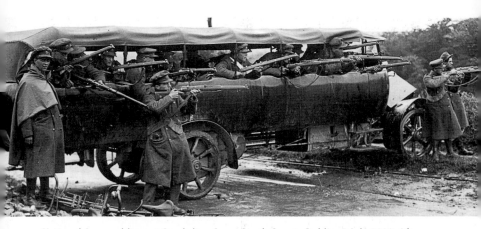

National Army soldiers at Crooksling Cross, South County Dublin, 5 July 1922. After the fighting in Dublin had ended, the battle moved to South County Dublin, where the Republicans had retreated. They were originally meant to have marched on Dublin to relieve the garrison in 'The Block', but the plan was never put into action.
Courtesy of Mercier Archives.

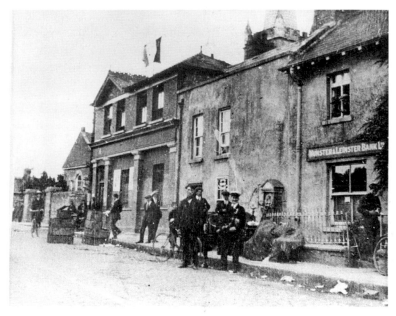

Anti-Treaty IRA barracks at Rathfarnham, 29 June 1922. Notice the Tricolour flying over the building.
Courtesy of Kilmainham Gaol Archives, 20PO-1A35-02.

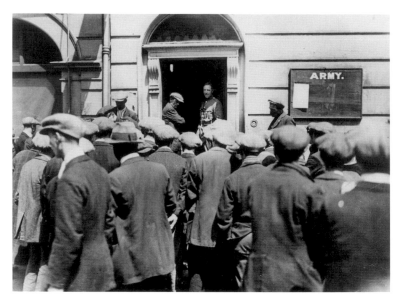

Crowds of men line up outside a National Army recruitment depot in Pearse Street, 7 July 1922. This was one of five such depots in the city set up by the government, which needed at least another 20,000 men to serve in the army to try to defeat the Republicans who had retreated to the south.

Courtesy of the National Library of Ireland.

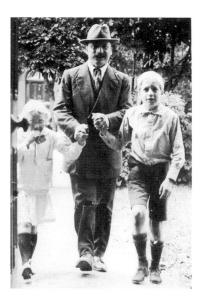

Arthur Griffith and his children, *c*. 1922. Griffith succeeded de Valera as President of Dáil Éireann in January 1922 after the Treaty was narrowly accepted by seven votes. He died of a cerebral haemorrhage on 12 August 1922. He was fifty years old.

Courtesy of the National Library of Ireland.

Michael Collins and Richard Mulcahy at the funeral of Arthur Griffith.

Courtesy of Military Archives Dublin, IE-MA-BMH-PC-253.

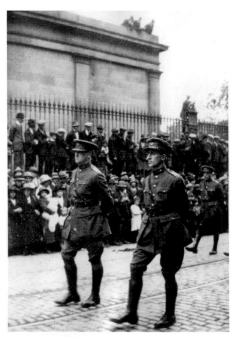

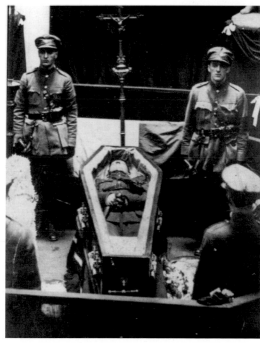

Michael Collins, who was shot and killed in Cork in August 1922, lying-in-state.

Courtesy of Diarmuid O'Connor.

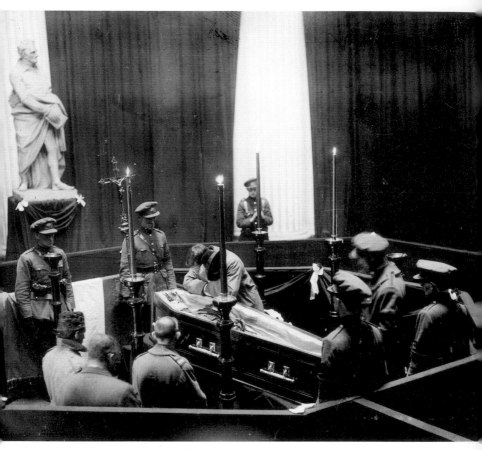

Seán Collins mourns the death of his younger brother, lying-in-state in City Hall, Dublin. Seán had seen Michael in Cork on his fateful last visit in August 1922. When he received word that Michael was dead he immediately set out for Cork city, travelling the same route that Michael had taken the day before. Seán and his driver were arrested by anti-Treaty soldiers, who took them to a farmhouse, and it was only on the orders of Tom Hales, commandant of the 3rd Cork Brigade, anti-Treaty forces, that they were released. This was the same Tom Hales who was part of the patrol that had lain in wait and ambushed Collins and his party at Béal na mBláth.

Courtesy of the National Library of Ireland.

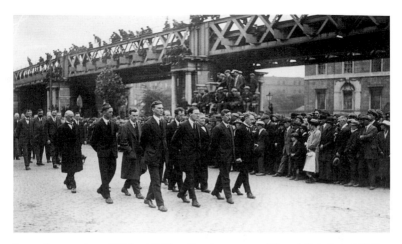

Funeral procession of Michael Collins. Front row, second from left, is Ernest Blythe; fourth from left is W. T. Cosgrave. Second row, on the left, is J. J. Walsh; third from left is Desmond Fitzgerald (behind Blythe). Eamonn Duggan is behind J. J. Walsh.
Courtesy of Mercier Archives.

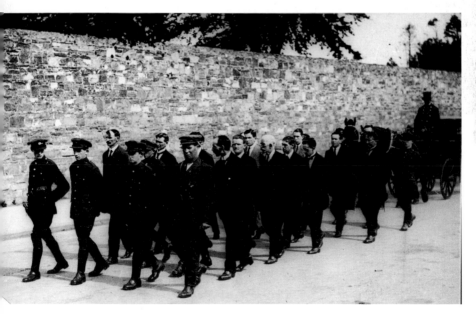

Members of Collins' family lead the procession into Glasnevin Cemetery.
Courtesy of the National Library of Ireland.

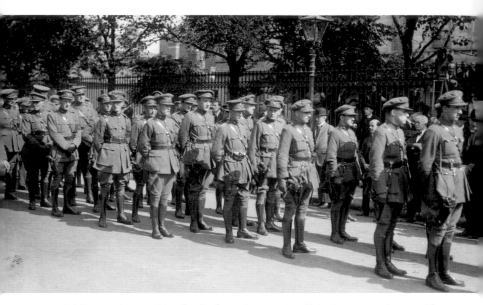

Soldiers get into position for the funeral procession. This photo was taken outside the Pro-Cathedral where the funeral mass took place. Minister for Home Affairs Kevin O'Higgins is in the fifth row, second from left. Sixth row, second from left is Adjutant-General Gearóid O'Sullivan.

Courtesy of the National Library of Ireland.

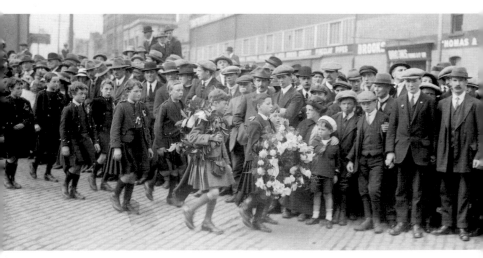

The Army Mascots carry floral tributes.

Courtesy of the National Library of Ireland.

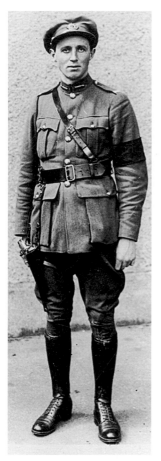

Major-General Tom Cullen, pictured here on the day of Collins' funeral. Cullen was Collins' body-guard at the time of his death, although he was not with Collins on that fateful trip to Cork. Like so many of his comrades, on both sides of the divide, Cullen did not live to see Collins' ideas realised, as he died in a drowning accident at Lough Dan, County Wicklow, on 20 June 1926. He was thirty-five years old.

Courtesy of Kilmainham Gaol Archives, 20PO-1A58-10c.

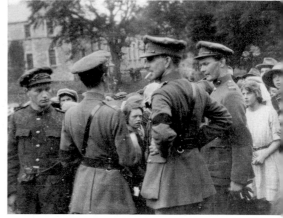

General Eoin O'Duffy (smoking cigarette) and General Michael Brennan (to the right of O'Duffy) amongst the crowds who turned out to pay their last respects to Collins.

Courtesy of Military Archives Dublin, IE-MA-PC-59.

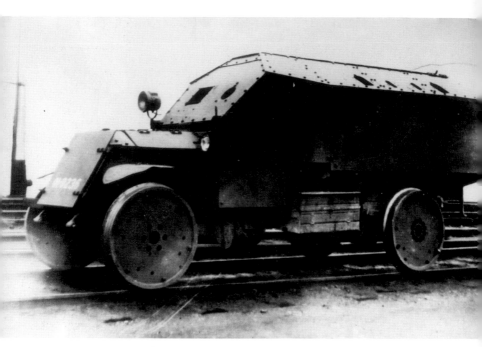

Armoured car used by the National Army during the Civil War. This was one of many such cars partly made in Inchicore Railway Works, 1922.

Courtesy of Military Archives Dublin, IE-MA-BMH-P-19-003.

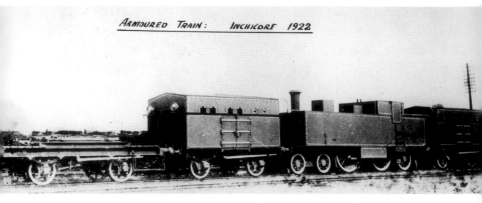

As the railways were targeted by the Republicans, the National Army had trains reinforced with armour plating, like the one seen here. Again the work was carried out in Inchicore Railway Works.

Courtesy of Military Archives Dublin, IE-MA-BMH-P-19-002.

A fleet of armoured cars that were partly fabricated in Inchicore Works.
Courtesy of Military Archives Dublin, IE-MA-BMH-P-19-004.

General Richard Mulcahy and his wife Min Ryan. Mulcahy was a veteran of the Easter Rising and the War of Independence. He was chief of staff of the IRA during the War of Independence until January 1922 when he became Minister for Defence in the Provisional Government. Upon Collins' death he became commander-in-chief of the National Army. This photograph was taken in the family home at Lissenfield, Rathmines, 1922.
Courtesy of the National Library of Ireland.

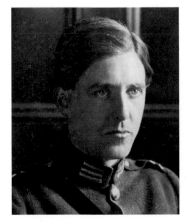

General Seán MacMahon. A veteran of the War of Independence, he served as quartermaster general of the IRA and took part in the burning of the Custom House in May 1921. He took the pro-Treaty side during the Civil War and upon Collins' death he became chief of staff of the National Army.
Courtesy of Military Archives Dublin, IE-MA-PC-253.

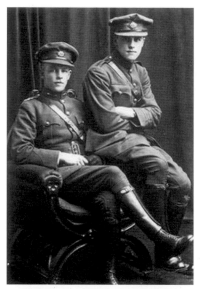

Emmet Dalton (*left*) and his brother Charlie. Emmet was a veteran of the First World War, and on his return to Ireland joined the Volunteers. He was director of munitions and became director of training in 1921. His younger brother Charlie joined the Volunteers in 1917, at the age of fourteen. He became a member of Michael Collins' Intelligence Unit and took part in many operations with the Squad, most notably on Bloody Sunday. Like his older brother he accepted the Treaty and joined the National Army upon its formation.

Courtesy of James Langton.

John McDonnell (*left*) and two unidentified Volunteers, taken in 1922. McDonnell was a member of A Company, 3rd Battalion.

Courtesy of Christopher McDonnell.

Peter Cassidy

John Gaffney

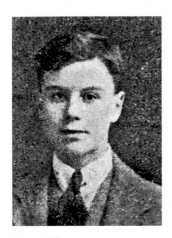

James Fisher

Richard Twohig

The first four men executed by the Provisional Government, 17 November 1922. All four had been arrested in October and were imprisoned in Kilmainham Gaol. Under the 'Special Powers Act' brought in by the government, they were tried by a military court on 9 November and executed by firing squad in Kilmainham eight days later. They were all from the Liberties area of Dublin. James Fisher was only eighteen years old. These were the first of seventy-seven 'official' executions carried out by the Provisional Government.

Courtesy of Martin O'Dwyer.

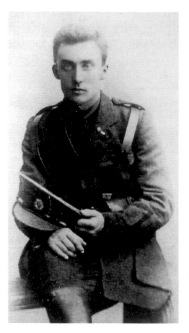

Peadar Breslin. A member of G Company, 1st Battalion, Dublin Brigade, Peadar had fought in the North King Street area during the Rising, after which he was imprisoned in Stafford Jail and Frongoch. Upon his release he rejoined his company and was involved in many operations throughout the War of Independence, including the raid on Collinstown aerodrome in 1918. He opposed the Treaty and joined his comrades in the Four Courts where he was appointed quartermaster. Imprisoned in Mountjoy Jail after the surrender he was shot dead during an attempted escape in October 1922. He left behind a widow, and two children: Rory, who was only one, and Peadar, who was born a few months after his father's death.

Christopher Breslin was the younger brother of Peadar. Unlike Peadar it seems that Christopher had no involvement in the revolution, as there has been no documentary evidence found to prove his involvement. He was, however, killed in suspicious circumstances in April 1923, by 'persons unknown'. Having been taken from his home by members of the National Army, his body was found on Cabra Road the next day, 30 April 1923.

Both photographs on this page courtesy of Peter McMahon and the Breslin family.

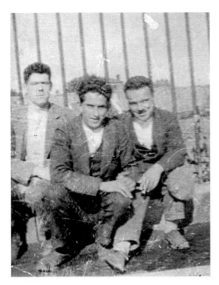

Left to right: Joe McHenry, Andy Cooney and Joe McKelvey. This photograph was taken in Mountjoy Jail. The date given is 7 December 1922, making this the last known photograph of Joe McKelvey, who was executed on 8 December with Dick Barrett, Liam Mellows and Rory O'Connor as a reprisal for the killing of Seán Hales TD on 7 December in Dublin.

Courtesy of Kilmainham Gaol Archives, 20PC-3N25-05.

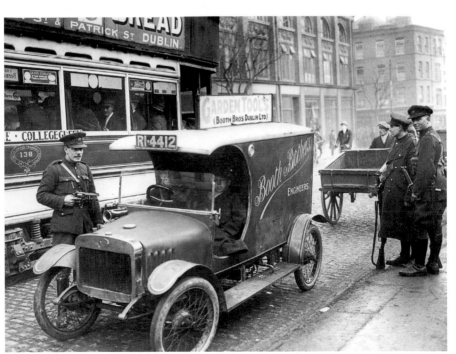

National Army soldiers search a vehicle in Dublin, December 1922.

Courtesy of Mercier Archives.

173

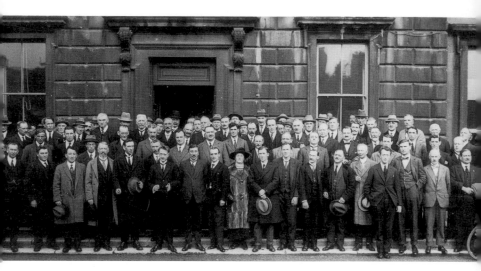

A group photograph of the Free State government outside Government Buildings 1922. Included in the photograph are Fionán Lynch, W. T. Cosgrave, Richard Mulcahy, Ernest Blythe and Desmond Fitzgerald.

Courtesy of Kilmainham Gaol Archives, 20PO-1A58-10.

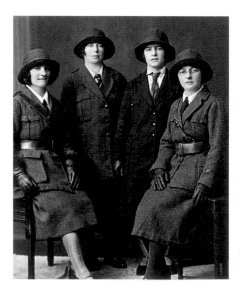

Women of the revolution. *Left to right*: Nellie Merrigan, Unidentified, Bridie Kavanagh, Kathleen Kavanagh (sisters). Nellie and Kathleen were sisters-in-law: Kathleen married Nellie's brother Tom. They took the anti-Treaty side during the Civil War. Nellie was engaged to be married but her fiancé took the pro-Treaty side and the relationship ended. Nellie and her younger sister Lizzie were arrested on 12 March 1923 by Nellie's former fiancé, who had joined the National Army. They were imprisoned in Kilmainham Gaol. Nellie died in 1989 aged ninety-one.

Courtesy of Kilmainham Gaol Archives, 18PO-1B53-17.

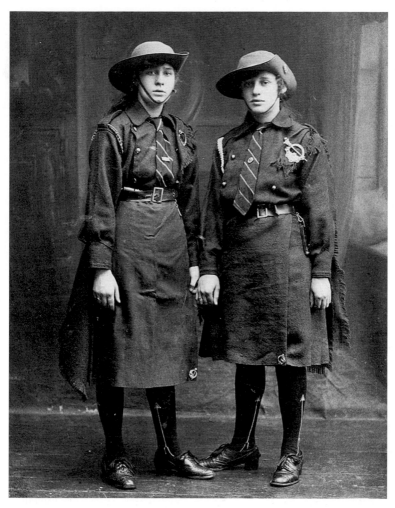

Lizzie Merrigan (*right*) and an unidentified girl *c*. 1915–16 wearing Cumann na nGaedhal uniforms. Cumann na nGaedhal was one of many nationalist bodies set up at the turn of the twentieth century with the aim of instilling in young people the ideas of nationhood and promoting Irish culture and identity. Established by the IRB, it was more extreme in its outlook than other nationalist bodies at that time. Like her older sister, Lizzie was a member of Cumann na mBan and took the anti-Treaty side during the Civil War. She was arrested with her sister in March 1923 and imprisoned in Kilmainham Gaol. She died in 1926 at the age of twenty-four.

Courtesy of Kilmainham Gaol Archives, 18PO-1B53-17.

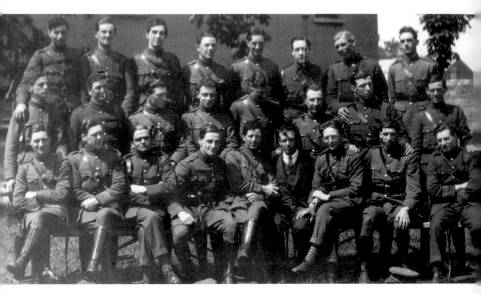

Pro-Treaty IRA staff, Portobello Barracks.
Courtesy of Diarmuid O'Connor.

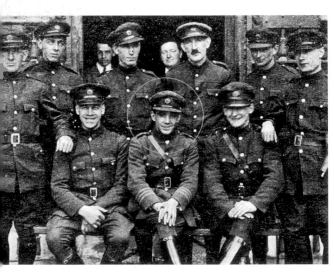

Commandant William Corri, pro-Treaty (*circled*), military governor of Kilmainham Gaol, and his staff outside the gaol in 1923. The Irish Civil War officially ended on 24 May 1923 with Frank Aiken's order to the anti-Treaty IRA to 'dump arms'. Although the conflict was over, mass arrests continued and thousands of Republicans were interred in prisons and internment camps across the country, including Kilmainham. Kilmainham Gaol, a symbol of resistance to so many on both sides of the conflict finally closed in 1924 after the last prisoner, understood to be Éamon de Valera, was transferred to Arbour Hill Prison, Dublin.

Courtesy of Kilmainham Gaol Archives, 20PO-1A35-18.

REMEMBRANCE

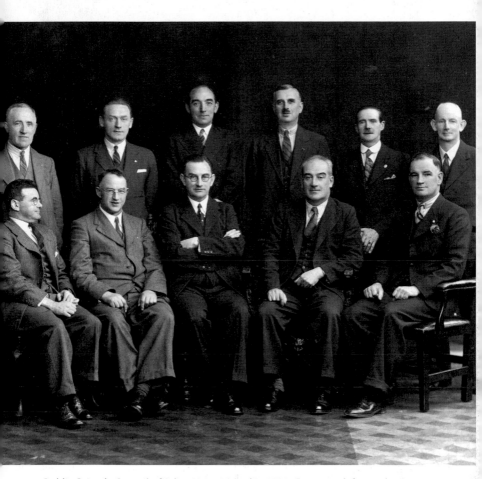

Dublin Brigade Council of July 1921, pictured in 1939. *Front row, left to right:* Commandants Andy McDonnell and Harry Colley, Brigade Commandant Oscar Traynor, Commandants Christopher O'Malley and Seán Mooney. *Back row, left to right:* Commandants Gerald Boland, Joseph Griffin, Paddy Holohan, Frank Henderson, J. J. Doyle, Tom Ennis.

Courtesy of Military Archives Dublin, IE-MA-ODB-01 Officers of the Dublin Brigade.

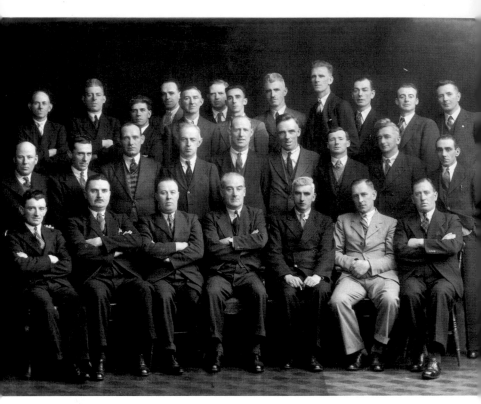

Members of the Active Service Unit (ASU), Dublin Brigade, pictured in 1939. *Front row, left to right:* James Carrigan, Thomas Flood, John Dolan, Christopher O'Malley, Pádraig O'Connor, Paddy Rigney, William Stapleton. *Middle row, left to right:* Robert Purcell, John Wilson, Patrick Brunton, Michael White, George Nolan, Patrick Collins, Joe McGuinness, Paddy Lawson, William Corri. *Back row, left to right:* Patrick O'Connor, Peter Larkin, John (Jack) Foy, M. Walker, Patrick Drury, Joseph Kavanagh, Joseph O'Carroll, George White, Seán Condron, Patrick Morrissey, James McManus, James Doyle.

Courtesy of Military Archives Dublin, IE-MA-ODB-01 Active Service Unit.

A commemoration held for Michael Collins and Arthur Griffith on 24 August 1947, the month of the twenty-fifth anniversary of their deaths.

Veterans walk into Glasnevin Cemetery.
Courtesy of Military Archives Dublin, E-MA-ODB-05 3rd photo, men walking into cemetery.

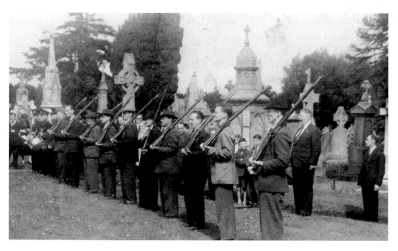

Presentation of arms at Collins' graveside.
Courtesy of Military Archives Dublin, IE-MA-ODB-05 8th photo, sideview of Guard of Honour.

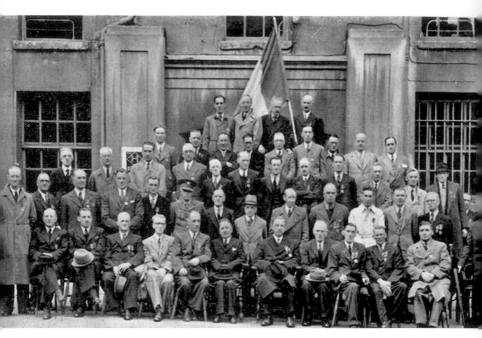

Surviving members of A Company, 3rd Battalion, Dublin Brigade, taken in 1948.

Back row, left to right: J. Bermingham, P. Lawless, H. Taylor, J. Clarke.

Fourth row, left to right: J. Bracken, W. Roe, C. Murray, Unidentified, P. Nolan, P. Hayes, J. McCormac, J. Bowden, J. Duffy.

Third row, left to right: P. O'Connell, S. McDonnell, L. O'Brien, P. J. McCormack, J. Byrne, Unidentified, M. Comerford, J. O'Reilly, J. Power, T. O'Rourke, P. Lynam, Unidentified.

Second row, left to right: J. Walsh, J. Guilfoyle, J. Hughes, J. Colman, M. Parkinson, W. Oliver, Wm Conroy, P. O'Brien, H. Gaines, T. Scully, J. Lynch, M. McEvoy, S. Murphy, P. McCormac.

Front row, left to right: J. Breen, S. Lemass, P. Byrne, C. Farrell, S. Keyes, H. Cahill, E. de Valera, J. O'Connor, O. Porter, J. Murray, M. Carroll.

Courtesy of Bernard Bermingham.

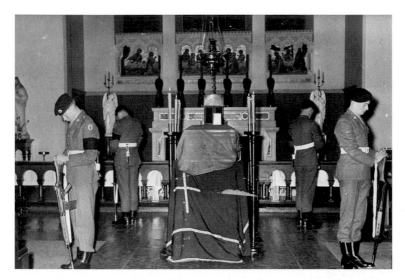

Coffin of Roger Casement lying-in-state in the Pro-Cathedral, Dublin 1965. His body was repatriated in 1965 and buried in Glasnevin Cemetery.
Courtesy of Kilmainham Gaol Archives, 21PC-1A53-17.

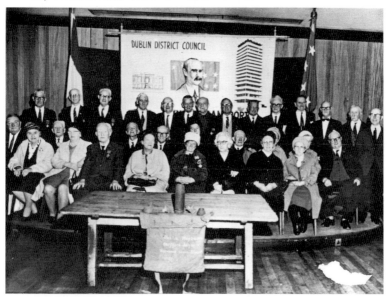

Survivors of the Irish Citizen Army of 1916, taken at Liberty Hall in 1966. In front of the group is the table on which the proclamation was signed in 1916.
Courtesy of Kilmainham Gaol Archives, 21PO-1A36-05.

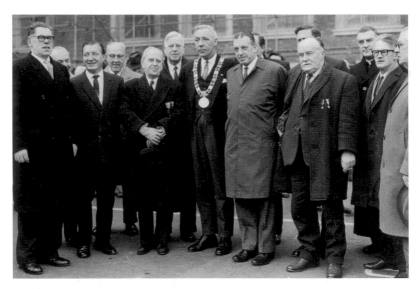

1916 Veterans gather in Dublin Castle for the fiftieth anniversary commemorations. Amongst those in the front row of the photograph are Joe McHenry, Charlie Haughey, Dr Jim Ryan and Seán Lemass. Third from the left in the back row is Joseph Cripps.

Courtesy of Kilmainham Gaol Archives, 2011.0238.

President Éamon de Valera and Vinny Byrne inspect the veterans at Dublin Castle.

Courtesy of Military Archives Dublin, IE-MA-PC-253, Scrapbook from Feb 1955 onwards P 2 Loose Photo – De Valera and Vinny Byrne.

Commemorations of the burning of the Custom House around the 1960s. The Guard of Honour fire a volley of shots to remember those who died during the operation.
Courtesy of Frank Lane.

Members of Cumann na mBan reminisce at one of their annual afternoon teas at the Gresham Hotel. Elizabeth O'Driscoll sits second from left.
Courtesy of Mick Doyle and Richard O'Driscoll.

SELECT BIBLIOGRAPHY

Abbott, Richard, *Police Casualties in Ireland 1919–1922* (Mercier Press, Cork, 2000)

Brennan, Robert, *Allegiance* (Browne and Nolan Ltd., The Richview Press, Dublin, 1950)

Briscoe, Robert and Hatch, Alden, *For the Life of Me* (Longman's, Green and Co. Ltd, London, 1959)

Caulfield, Max, *The Easter Rebellion* (Gill & MacMillan, Dublin, 1995)

Coogan, Tim Pat and Morrison, George, *The Irish Civil War* (Weidenfield and Nicholson, London, 1998)

Dalton, Charles, *With the Dublin Brigade 1917–1921* (Peter Davies, London, 1929)

Deasy, Liam, *Brother Against Brother* (Mercier Press, Cork, 1998)

Dywer, T. Ryle, *The Squad and the Intelligence Operations of Michael Collins* (Mercier Press, Cork, 2005)

Fallon, Las, *Dublin Fire Brigade and the Irish Revolution* (South Dublin Libraries, Dublin, 2012)

Fitzgerald, Redmond, *Cry Blood, Cry Erin* (Vandal Publications, London, 1966)

Fox, R. M., *The History of the Irish Citizen Army* (James Duffy and Co. Ltd, Dublin, 1944)

Foy, Michael T., *Michael Collins and the Intelligence War* (Sutton Publishing, UK, 2006)

Foy, Michael T. and Barton, Brian, *The Easter Rising* (Sutton Publishing, UK, 1999)

Gillis, Liz, *The Fall of Dublin* (Mercier Press, Cork, 2011)

Gleeson, James, *Bloody Sunday* (Peter Davies, London, 1962)

Greaves, C. Desmond, *Liam Mellows and the Irish Revolution* (An Ghlór Gafa, Belfast, 2004)

Griffith, Kenneth and O'Grady, Timothy E., *Curious Journey: An Oral History of Ireland's Unfinished Revolution* (Hutchinson and Co. Publishers, London, 1982)

Hegarty, Peter, *Peadar O'Donnell* (Mercier Press, Cork, 1999)

Hopkinson, Michael, *Green Against Green: The Irish Civil War* (Gill & MacMillan, Dublin, 1998)

— *The Irish War of Independence* (Gill & MacMillan, Dublin, 2004)

Kiberd, Declan, *1916 Rebellion Handbook* (The Mourne River Press, Dublin, 1998)

Kerryman, *Dublin's Fighting Story 1916–1921: Told by the Men Who Made it* (Tralee, no date)

Lawlor, Damien, *Na Fianna Éireann and the Irish Revolution 1909–1923* (Caoillte Books, Ireland, no date)

Litton, Helen, *The Irish Civil War: An Illustrated History* (Wolfhound Press, Dublin, 1995)

— *Kathleen Clarke: Revolutionary Woman* (O'Brien Press, Dublin, 2008)

McCoole, Sinead, *Guns and Chiffon* (Government Publications Stationery Office, Dublin, 1997)

— *No Ordinary Women* (O'Brien Press, Dublin, 2003)

Macardle, Dorothy, *The Irish Republic* (Irish Press Ltd, Dublin, 1951)

MacEoin, Uinseann, *Survivors* (second edition, Argenta Publications, Dublin, 1987)

Mannix, Patrick, *The Belligerent Prelate* (paperback edition, Cambridge Scholars Publishing, Newcastle, 2013)

Matthews, Ann, *Renegades: Women in Irish Republican Politics 1900–1922* (Mercier Press, Cork, 2010)

— *Dissidents: Irish Republican Women 1923–1941* (Mercier Press, Cork, 2012)

Mulcahy, Ristéard, *Richard Mulcahy (1886–1971): A Family Memoir* (Aurelian Press, Dublin, 1999)

National Graves Association, *The Last Post* (third edition, Elo Press, Dublin, 1985)

Neeson, Eoin, *The Civil War 1922–23* (Poolbeg Press, Dublin, 1995)

O'Brien, Paul, *Blood on the Streets: 1916 and the Battle for Mount Street Bridge* (Mercier Press, Cork, 2008)

— *Uncommon Valour: 1916 and the Battle for the South Dublin Union* (Mercier Press, Cork, 2010)

— *Crossfire: The Battle for the Four Courts 1916* (New Island Press, Dublin, 2012)

Ó Broin, Leon, *Revolutionary Underground: The Story of the IRB 1858–1924* (Gill & MacMillan, Dublin, 1976)

O'Connor, Diarmuid and Frank Connolly, *Sleep Soldier Sleep: The Life and Times of Padraig O'Connor* (Miseab Publications, Kildare, 2011)

O'Dwyer, Martin, *Seventy-Seven of Mine Said Ireland* (Cashel Folk Village, Tipperary, 2006)

— *Death Before Dishonour* (Cashel Folk Village, Tipperary, 2010)

O'Farrell, Mick, *A Walk Through Rebel Dublin 1916* (Mercier Press, Cork, 1999)

O'Farrell, Padraic, *Who's Who in the Irish War of Independence and Civil War 1916– 1923* (The Lilliput Press, Dublin, 1997)

O'Malley, Cormac K. H. and Dolan, Anne, *No Surrender Here: The Civil War Papers of Ernie O'Malley 1922–1924* (The Lilliput Press, Dublin, 2007)

O'Malley, Ernie, *The Singing Flame* (Mercier Press, Cork, 2012)

Ó Ruairc, Pádraig Óg, *Revolution: A Photographic History of Revolutionary Ireland 1913–1923* (Mercier Press, Cork, 2011)

Pinkman, John A., *In the Legion of the Vanguard* (edited by Francis E. Maguire, Mercier Press, 1998)

Regan, John M., *The Irish Counter Revolution, 1921–1936* (Gill & MacMillan, Dublin, 1991)

Robbins, Frank, *Under The Starry Plough: Recollections of the Irish Citizen Army* (The Academy Press, Dublin, 1977)

Sheehan, William, *Fighting for Dublin: The British Battle for Dublin 1919–1921* (Collins Press, Cork, 2007)

Valiulis, Maryann Gialenella, *Portrait of a Revolutionary: General Richard Mulcahy and the Founding of the Irish Free State* (Irish Academic Press, Dublin, 1992)

Ward, Margaret, *In Their Own Voice* (Attic Press Ltd, Cork, 2001)

Younger, Calton, *Ireland's Civil War* (Fontana Books, London, 1970)

ACKNOWLEDGEMENTS

There are so many people to thank who helped make this book become a reality. Firstly my thanks to Mary Feehan, who suggested that I do the book, and all the staff at Mercier Press: Wendy, Sharon, Patrick and Niamh, and to Andy Hawes. I would also like to thank the staff at the National Library, Ireland, in particular Glenn Dunne, Berni Metcalfe, Nora Thornton, Keith Murphy and William Doyle.

I am indebted to Niall Bergin and Anne-Marie Ryan, Kilmainham Gaol Museum and Archives, who were more than generous with their time in copying images and checking details and references for me, often with very little notice, and also to my colleagues and friends in Kilmainham Gaol. To those who have since moved on and those still there, a huge thank you. You are all a great group of people whose encouragement and support is very much appreciated.

To the staff of Military Archives I cannot thank you enough: Commandant Victor Laing (retired), Commandant Padraic Kennedy, Captain Stephen MacEoin, Private Adrian Short, Corporal Andy Lawlor, Lisa Dolan, Noelle Grothier, Hugh Beckett, Captain Claire Mortimer, Sergeant David Kelly, C QMS Tom Mitchell and Lieutenant Deirdre Carberry. Your dedication to the archives and your kindness in helping me with this work was just amazing and all I can say is thank you.

Throughout the research of the book I was so fortunate to have met so many wonderful people, whether they were the relatives of those who had taken part in the revolution or who just have a love of our history. I am so very grateful to Áine Broy, Bernard Bermingham, Carol Mullen, Chris Dalton, Paddy Kelly, Catherine Long, Kate Walton,

Sheila Maguire, Michael Manley, Kathleen Cregan-Quadrato, Mike Connolly, Eanna Connolly, Liam Doyle, Mick Meehan, Frank Lane, Joe Bevan, Stephen McDonnell, Matt Doyle, Stephen Byrne, Liam Ó Duibhir, Pádraig Ó Ruairc, Tony Kinsella, Pearse Cafferky and the family of Oscar Traynor, Philip Rooney and Peter and Christopher Duffy, Mick Doyle and Richard O'Driscoll, the Breslin family, Gary Deering, Eamon Murphy, Diarmuid O'Connor, James Langton, Ed Penrose and Terry Fagan. Without fail you were all so generous with your time and knowledge. Without you this book would not have been possible. You were all so kind in supplying photographs and answers to my queries, even if it was an email or text at twelve o'clock at night. I tried to make this book about the people of the revolution, and you are the people who helped me to do this. Thank you.

Thanks also to Peter McMahon, Martin O'Dwyer (Bob), Patrick Mannix and Dr Shane Kenna – your support and encouragement mean a great deal. My thanks to Paul O'Brien and Las Fallon, two great friends and also two great historians. To Mícheál Ó Doibhilín, my history tag-team mate, what can I say, you're just brilliant and I am forever grateful for all your help with this book and I thank you from the bottom of my heart.

To my family and friends, you have always supported me in whatever I have chosen to do and words just cannot describe how much you mean to me. John, Pat, Mikey, Pheobe, Gerry, Lydia, Jack, Aunt May and my extended family, thank you. My sister Mimi, you're a trooper and I love you so much. Uncle Pat, your encouragement and support knows no bounds and you are the best uncle anyone could ever have. And to my fiancé James, once again you have encouraged, listened, endured and even walked up mini mountains with me, all in the name of Irish history and I am truly grateful for your love and support.

Finally to my dad, Mick: just like Gran you are an inspiration and all I can say is, 'Thank you for the days, Those endless days, Those sacred days you gave me …'

INDEX